FATHERS & SONS

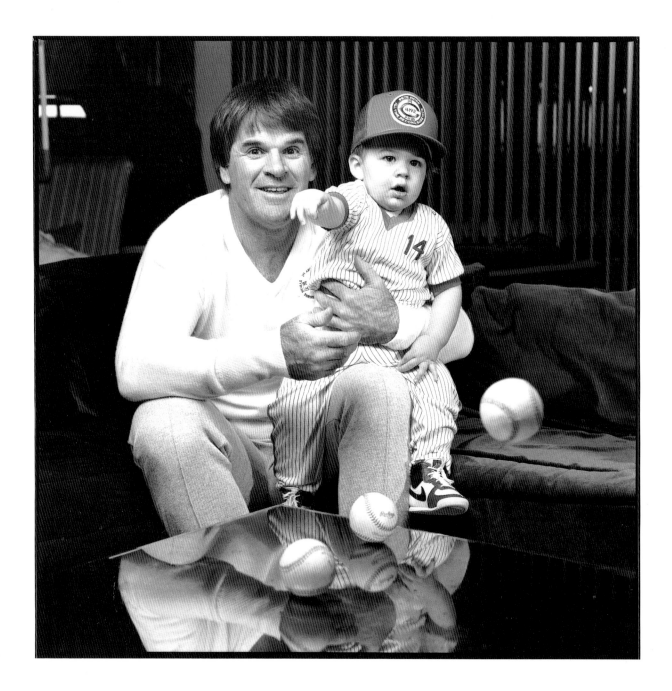

Photographs by Steven Begleiter

FATHERS & SONS

Abbeville Press · Publishers · New York

To the memory of my father, Jack, who will always be my hero.
To my sister Melodie, whose memory gives me
the strength and inspiration to carry on with my art.
To my mentor Tommy Weihs and my guardian angel Mike Fuller.

Editor: Alan Axelrod
Designer: James Wageman
Production manager: Dana Cole

Library of Congress Cataloging-in-Publication Data

Begleiter, Steven.
Fathers and sons.

1. Photography—Portraits. 2. Fathers
and sons—Pictorial works. I Title.
TR681.F34B44 1989 779'.23 88-8011
ISBN 0-89659-968-X

Jacket front: Bill Cosby, entertainer and author, with Ennis
Jacket back: Kirk Douglas, actor, with Eric
Frontispiece: Pete Rose, Cincinnati Reds manager, with Ty

CONTENTS

PREFACE

I started *Fathers and Sons* in 1983. Amy—then my girlfriend, today my wife—had a friend who wanted his photograph taken. It was Murray Horwitz, coauthor of the Broadway musical *Ain't Misbehavin'*, who wanted a portrait with his son. The idea didn't really excite me at first, since I wasn't sure where this work would fit into my portfolio. I spoke to Murray about it, and he told me that he had been in the circus in his younger days and would like to be in clown make-up when I photographed him and his son. This began to intrigue me. So I suggested his son also wear clown make-up. Murray came to my studio, along with his wife and three-month-old daughter, as well as his son. As they put on their make-up in the bathroom and the little girl continued to cry, I thought of the baby pictures my mother displayed on the TV set.

What I felt was despair. Was I to become a baby photographer? Open a store-front studio and photograph bawling babies for the rest of my life? That had not been my intention when I went to photography school, nor when I spent four years assisting some of the top photographers in America.

When Murray and Alexander came out of the dressing room and I saw the smiles and warmth they both generated, my despair faded into the sound of my shutter snapping away. By the end of the session I felt very satisfied.

On assignment a couple of weeks later, I met John Irving and asked if he would be interested in posing for a portrait with his son. He agreed and came down to my studio with Colin. I knew how he and his son loved wrestling, and I knew that I would want to pose them in some sort of wrestling position. After shooting several rolls, I placed them close together, and Colin put John in a ham-

merlock. That was the photo I was looking for. And, observing their relationship through the camera, I found myself envying what was going on: a father *involved* with his son.

I was the son of an invisible father. Growing up in Cleveland Heights, Ohio, the only time I saw him was when he came home, late at night, exhausted from work. My mother had his dinner ready, he ate while watching TV, then fell asleep in his chair. Seven days a week. I was around six when my mother finally took me to my father's business, and I got to see this stranger at work. He was the proprietor, sales clerk, and stock boy of an army-and-navy store in an East Cleveland ghetto. A year after my first visit, I began working summers for him. I was hoping to learn—not about his business, but a little about him. My efforts were in vain.

It was true that my father was a Holocaust survivor. Perhaps the wounds inflicted by that horror meant he *couldn't* get close to me—or, perhaps, he was just part of a generation of men who did not believe it was the father's responsibility to raise the children. I don't know. But I do know that my father was a kind and gentle person, a man I would like to have known better. He died in 1984, leaving behind a lot of unanswered questions.

Maybe I started taking portraits of fathers and sons to find some of the answers.

The next photo session was with Paul Dooley and his son. He told me that he had not seen Adam for about ten years because of a bitter divorce. When Adam

turned eighteen, he decided to live with his father. This is when I met Paul; he saw my work and asked if I would be interested in doing a portrait. I had no doubt that this would make a good photograph.

A friend of mine at *Life* had seen about ten of my portraits of fathers and sons and suggested I do more for a possible spread in the magazine. This sent me brainstorming for fathers and sons to photograph. I asked all my friends and portrait subjects for recommendations, and the lists started to come in. I made phone calls and sent out information packets. The response was extraordinary. Only one in ten declined.

I had done about thirty portraits by the time I submitted them to *Life*. After about three weeks, they decided to go ahead and publish six in their June 1985 issue. I was on top of the world.

A week before the prints were to go to press, *Life* underwent some personnel changes, and the June issue was redone. Entirely. Without my portraits.

My book agent, meantime, suggested that I continue doing portraits while she showed my work to publishers. So I went on, going to California, to photograph Kirk and Eric Douglas, and Mel and Noel Blanc—which turned out to be the funniest photo session I've ever had. Mel, the voice of Bugs Bunny (among five hundred other cartoon characters), talked to his son in one of his cartoon voices, and his son replied in another. It was sheer fantasy, but real.

I was meeting these wonderful people who opened a little bit of their private lives to me, a stranger, and invited me into their homes and made me feel, at times, part of the family. What surprised me the most is that after they had gone

out of their way, getting their family together, taking the time out to sit for me, they always thanked me.

After a year of searching for a publisher, my agent gave up. She returned my material and wished me the best of luck. Three years after I had started the project, I was beginning to feel the emotional and financial toll. As passionate as I had become about taking portraits of fathers and sons, I realized I couldn't do any more without backing. I put the project to rest.

About a year later, in October 1987, three weeks before I was to be married, a friend of mine, Abe Frajndlich, told me about the Frankfurt Book Fair, where most of the world's publishers gather annually to buy and sell projects. Abe suggested I go to Germany and look for a publisher. Two weeks before my wedding date, I went.

It was the last minute, and there were no rooms left in Frankfurt. I called up the wife of a friend and asked if she knew of anyone in the city. It turned out that her father had a friend who had just moved out of his old apartment about twenty minutes from Frankfurt. I could stay there. But, I was warned, there was no furniture.

When I arrived, I set down my sleeping bag in the middle of the empty room, slept till noon, and traveled to the book fair—only to discover that it was closed to the public until later in the afternoon. The trouble was that most of the key people would have left *before* noon. I got there early the next day, found a group of Americans going through the gate, each with a plastic-covered convention badge. I joined them, flashing my naked lapel.

I was in.

And I found Abbeville Press, whose president—fortunately for me—is a father of four, including three sons. He understood my work and wanted to publish my photographs. After five years, I finally had my audience.

I hope this book will remind fathers that it is okay to show their feelings of love—before their children become strangers.

–Steven Begleiter

In the process of its making, this book has become very "personal property" for me. Ideally, it should now become the personal property of the father who buys it or is given it. I invite him to make this book his by recording on the facing page his own thoughts on fatherhood and by pasting on this page his own father-and-son portrait. –S.B.

John Irving

novelist, with

Colin

Having children is inseparable from how I see myself as a writer—loving them, and responding to their love; like writing, they demand constancy. Being a father is a permanent vulnerability; there is no love or responsibility without that risk, without the courage to make yourself vulnerable. My children are my greatest teachers.

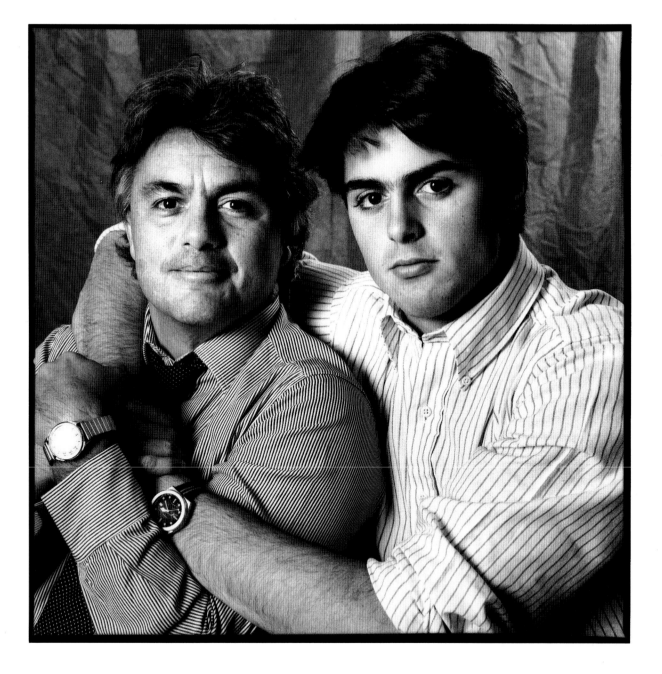

Austin Carr

former Cleveland Cavalier, with

Jason

Other than a great game, there's nothing that got my adrenaline going like the times when my kids were born. I was a bachelor all through my professional career, and I realized that becoming a father was something I needed to do to help me develop. And it has. I've always tried to be a couple steps ahead, but kids make you stay fifteen steps ahead. I never thought I'd be someone who looks into a crystal ball, trying to figure how things will be in twelve years—but you have to, you have to have a game plan.

One word we use around the house a lot is love, *and the kids understand it and aren't afraid to use it. They've really taught me how to express love, which I didn't do too much of in the past—being an athlete, which sometimes makes you keep your feelings inside. It's a whole other ballgame now.*

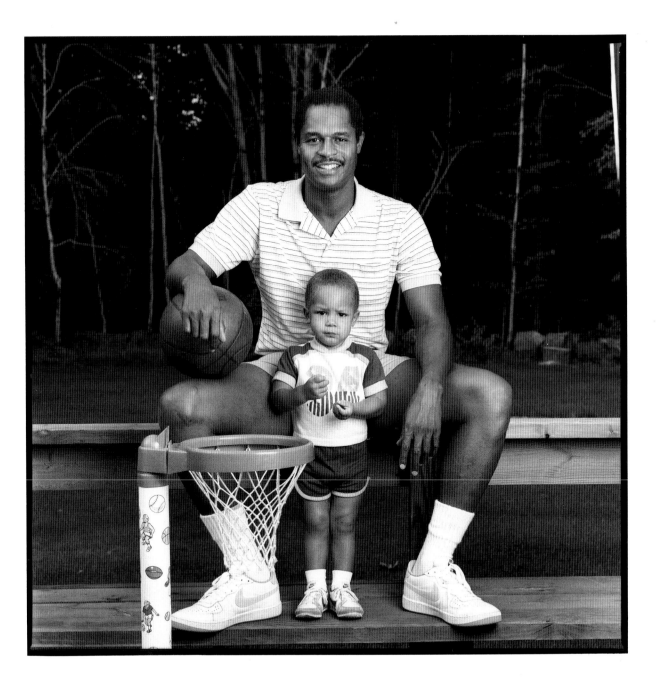

Dave Fisher

retired Postal Service worker, with

Alan

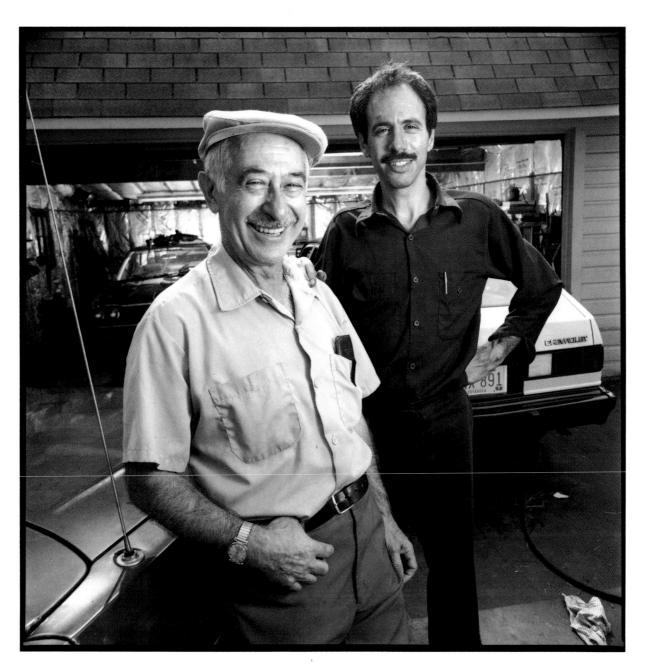

Alan Arkin

actor, director, writer, with

Matthew, Adam, *and* Anthony

I don't know what being a father is. We've all gone through so many changes in the past few decades that I can't easily define the experience anymore. But I know a little about friendship. Being a friend means being able to rely on someone past comfort or even reason. Hearing the call for help and saying, "I'll be right there." No questions asked. These three guys have been my friends for a long time now. I think I'm theirs, too.

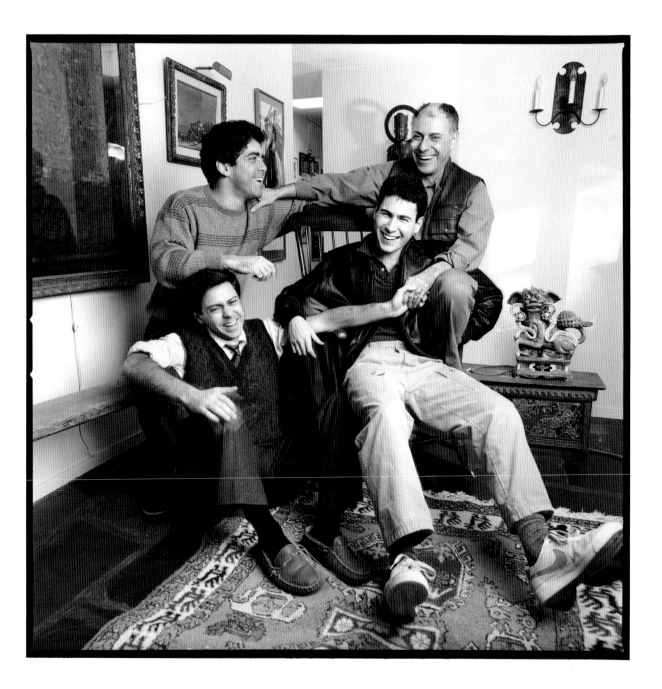

Massimo Vignelli

designer, with

Luca

The basic condition of parents in relation to their children is apprehension. As a father, I lived from day one in that state, and I continue to live in that condition today. Issues of health, education, safety, and career continually overlap each other, leaving you in a state of chronic apprehension. No matter how good the son or daughter, the apprehension is there. The better the child, the higher the apprehension, because the higher the prize.

There is no trust, confidence, praise, respect, or love that can erase apprehension. It is there because the child is there. That is the human condition.

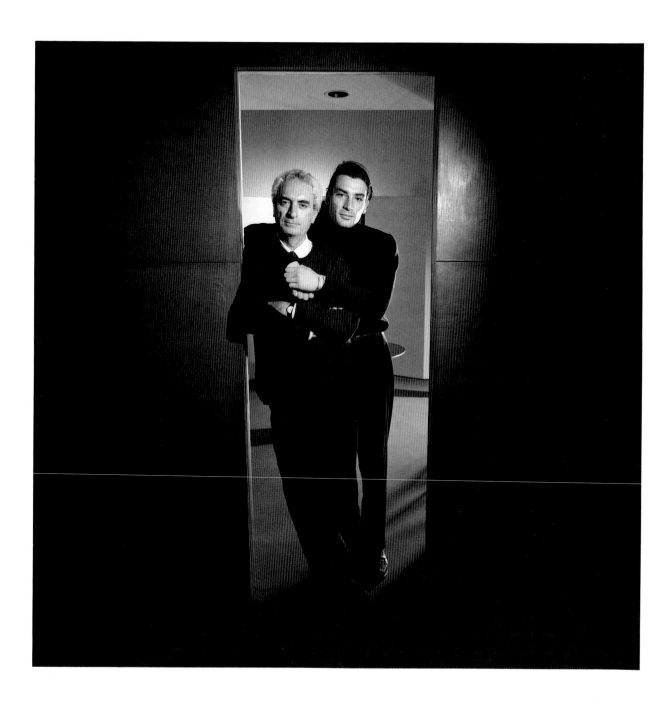

Loudon S. Wainwright

writer, with

Loudon III *and grandson* Rufus

Fatherhood has been the most powerful continuing experience in my life.

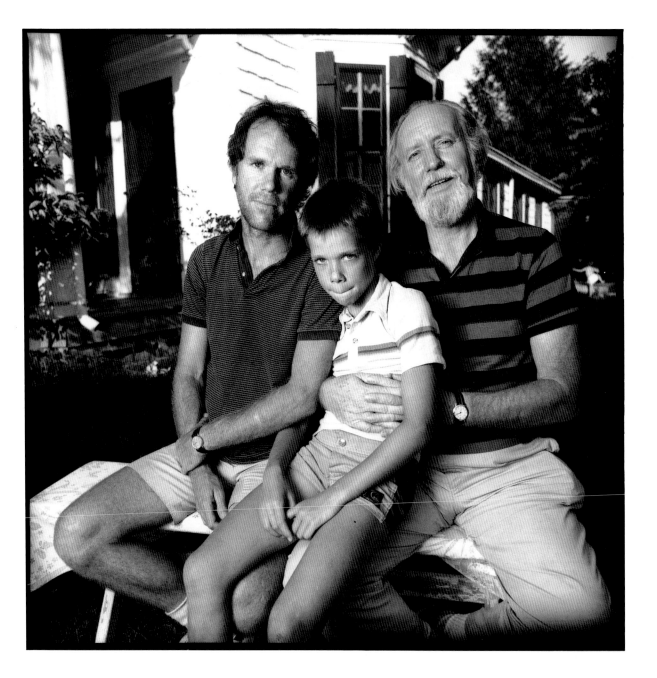

William T. Williams

artist, with

Aaron

Being a parent has made me reflect on the past, aware of the present and its ultimate effect on the future. My hopes and dreams are with my family.

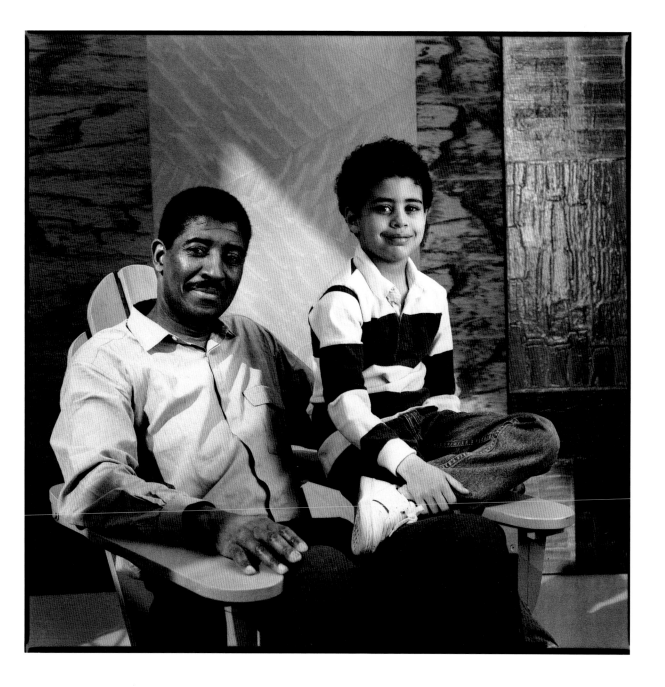

Malcolm Forbes

publisher of Forbes Magazine, *businessman, and collector, with*

Kip, Steve, *and* Bob

Becoming a father enhances one's life nearly as much as getting married does. And it's enriching—at no matter what cost—beyond comprehension. We had a ball with the kids.

As to raising children, raising parents, I think, is far harder. Parents need to cease parenting—they've done their job—by the time the kids are sixteen or seventeen. If you want to keep your children, you have to let them go and change with them. Be responsible, but above all, enjoy them as people.

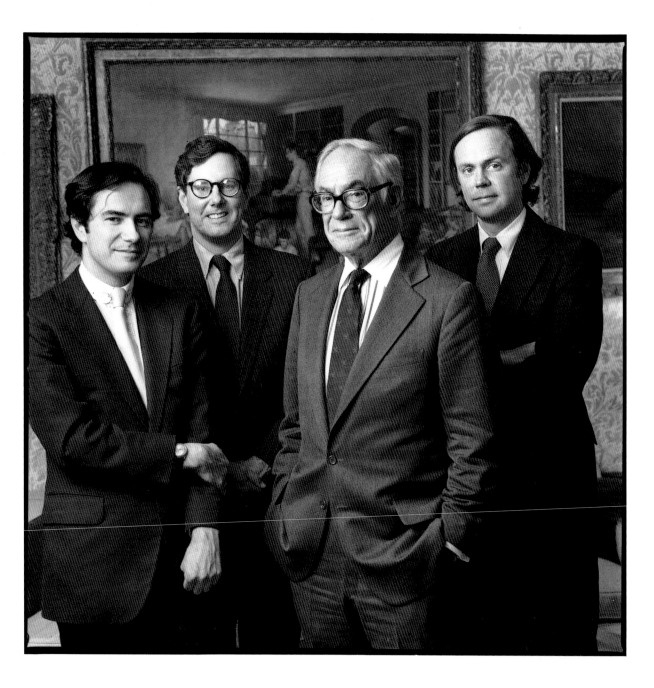

Gordie Howe

former Hartford Whaler forward, and vice-president, Howe Enterprises, with

Marty, Mark, *and* Murray

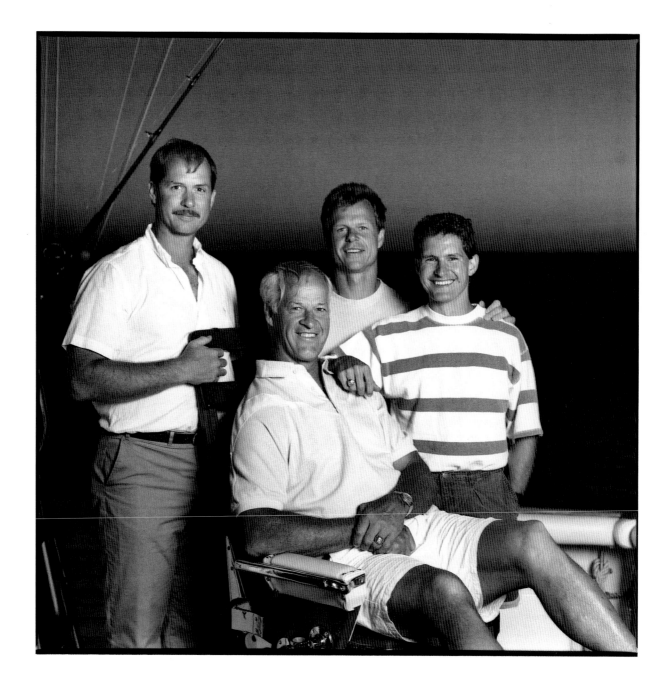

Earl Robinson

musician and composer, with

Perry

Becoming the father of my son, Perry, was both an easy and a hard experience. My wife became sick with toxemia during the latter part of the pregnancy, and when the doctors finally, in her eighth month, had to induce labor, they gave the baby one in ten chances of living. When I asked about the baby, their answer was, "We save Helen, the factory, before worrying about the product." So Perry came out weighing just three pounds, ten ounces and lost weight the first four days. Fed with an eye dropper at first, he began to gain an ounce a day. And he proved to be indestructible.

In terms of change in my life, I have always been very personally directed toward my goals, my career. The somewhat narrowly selfish Earl has changed and grown in compassion. I was strongly challenged, early on, by Helen's sickness and Perry's sturdy and winning struggle to live and grow. At the age of seventy-six I am still learning to be a father.

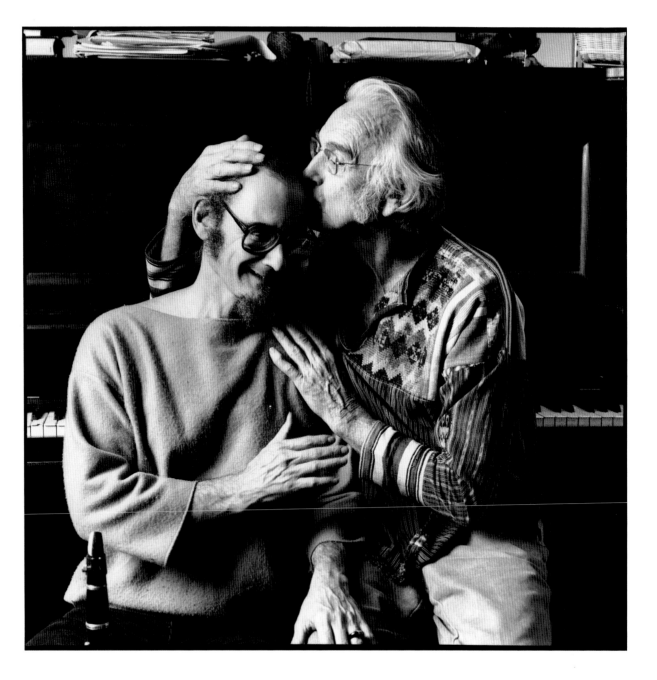

Mike O'Neal

restaurateur, with

Coke

You don't go to school to learn how to be a father. There are no classes in high school or college. Every day there are surprises. No one said it was going to be easy.

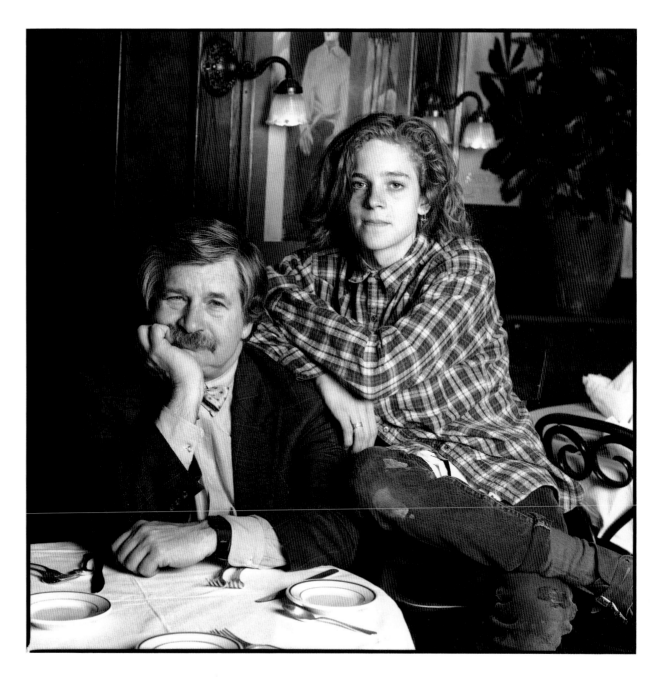

Mario Andretti

champion race-car driver, with

Michael

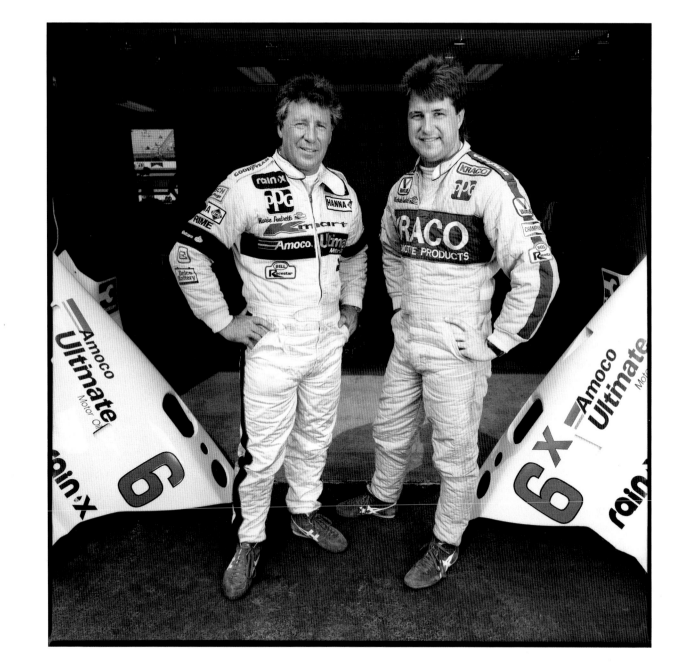

Dave Shewmon

sales manager, North American Refractory Company, with

Michael *and* Derek

Becoming a father fulfilled my life because it added a sense of immortality, with my life and spirit being passed on to future generations through my children. It also enabled me to relive my childhood through the disguise of being a parent, as I play with my children and their toys. I think each one of us maintains our childhood memories and fantasies. Being a parent allows us to release them.

I will always cherish and love my children and thank them for allowing me to fulfill my life and my dreams.

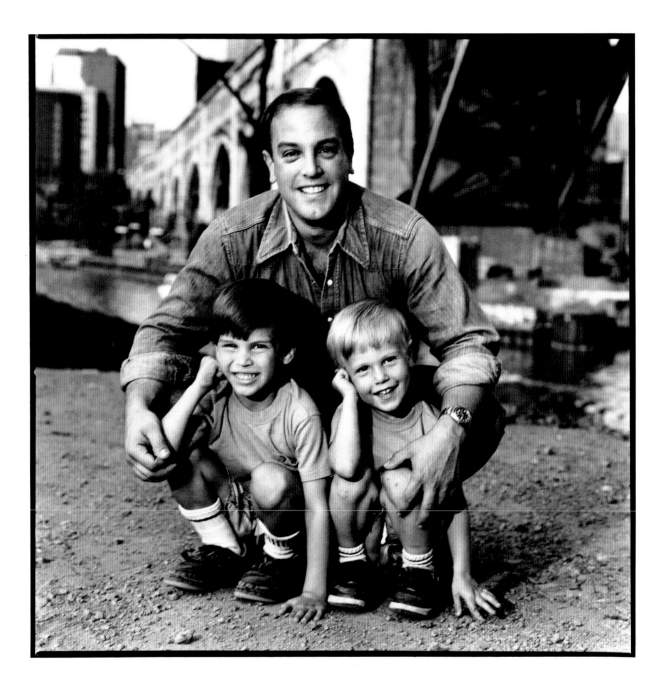

Rafer Johnson

*Olympic medalist, and president,
California Special Olympics, with*

Joshua

*It is as if fatherhood made me a
complete person. I don't think there
has been anything that made me
feel the way I felt when I saw my
children a few moments after they
were born. The Olympic Silver Medal
in 1956, the Olympic Gold Medal of
1960, and the opening of the Olympic
Games of 1984 all were great and
wonderful moments, but none
match looking into the newborn
faces of Joshua and Jennifer.*

*To see them grow and learn has
been a glorious experience. Josh and
Jenny have made me proud to be
a father.*

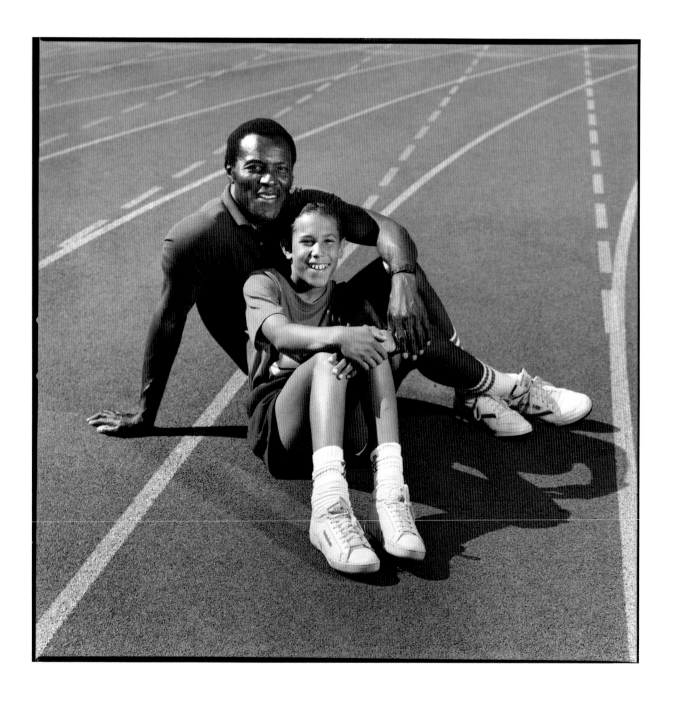

Eugene Oberst

retired professor of history and political science, 1924 Olympic medalist, with

Eugene, Jr., Albert, *and* Robert

Born in 1901, youngest of eleven children, I grew up in the period of the late Victorian family. With six married brothers as models, I anticipated all the responsibilities and joys of raising a family; consequently, when my first son arrived (the first child of five), there was no change in my life-style.

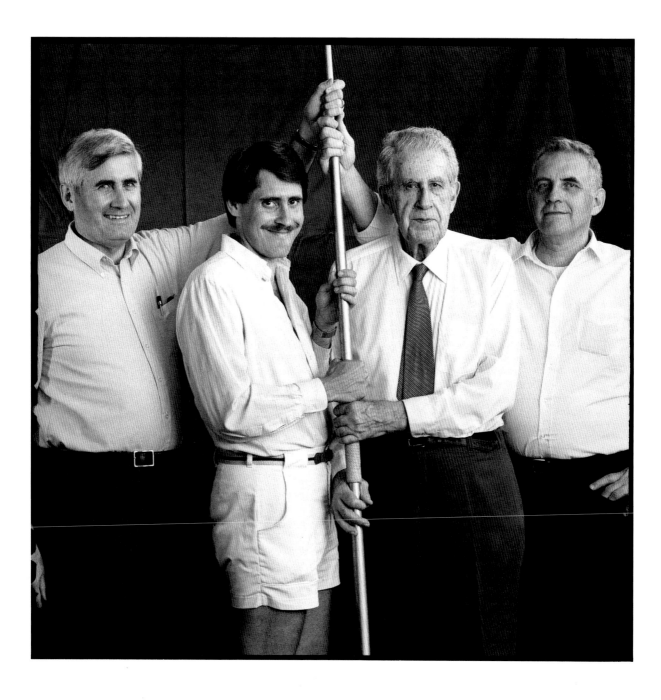

Jonathan Winters III

comedian and writer, with

Jonathan IV

My son, in many ways, has meant so much. When I was depressed, down, and needed encouragement, it was my boy who boosted my morale. We're both fans of one another. He was MVP on his high school baseball team, he lettered in football, he graduated from college. He's a builder and a contractor, and a good one. He's got a great sense of humor.

He's somewhat of a loner, like me, and a rebel, a true nonconformist. I've always instilled in him that the most important thing is to try to be your own man. I've always said, Everybody bends; I just didn't bend over! Whatever rewards, accolades, goals I've missed in life, having a son has made up for all that!

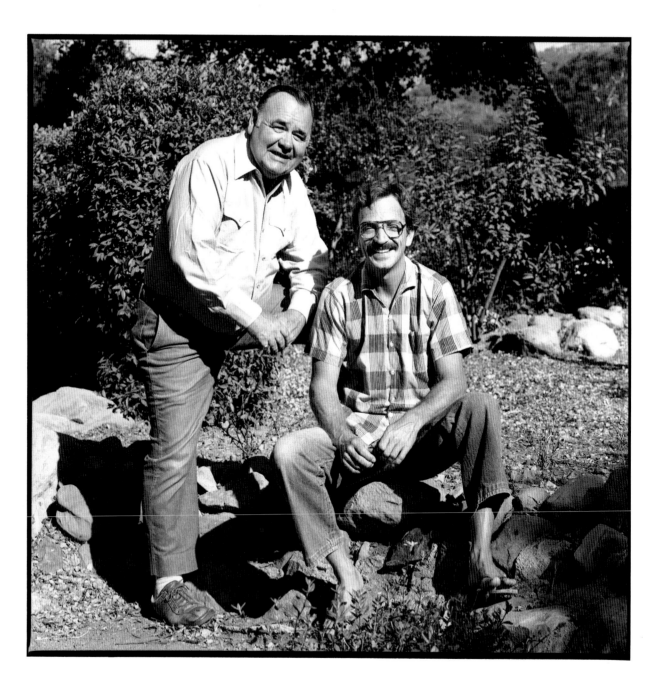

Gil Eisner

illustrator, with

Jake

Fatherhood exercised a responsible part of me that needed the workout. The grim awareness of a crying child at three A.M. is more than balanced by the satisfaction (not just the relief) of getting him to fall asleep on your shoulder twenty minutes later. I felt needed, and when he began to recognize me and went to sleep right away, I felt like a champ. When he eats my roast chicken or gobbles the sauteed liver, I swell.

At five years old he's got an idea of right from wrong, he can cast a spinning lure with some accuracy, fungo a plastic baseball fifty feet, and, on seeing his three-year-old sister cry because there were no strawberries left, put his arm around her. I'm so proud of him, proud of his creativity, his compassion, and his physicality. I didn't know the power of those feelings before becoming a papa.

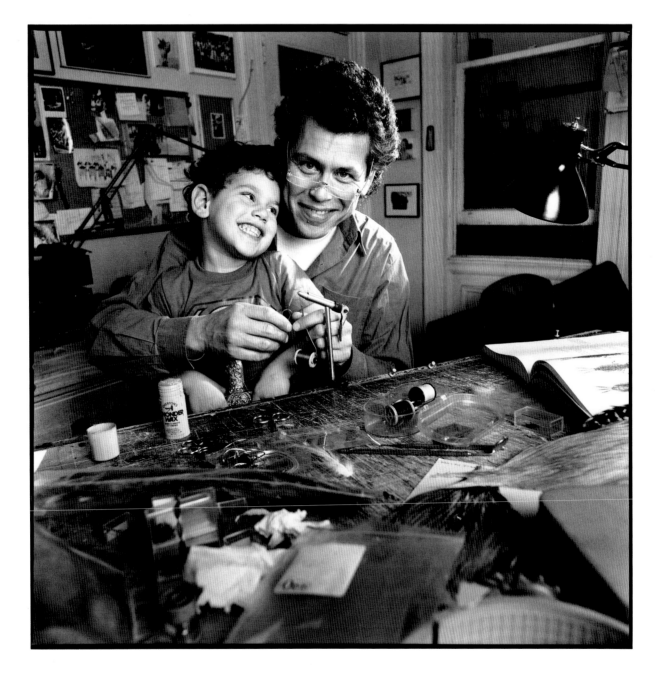

Gerald McConnell

publisher, with

Kevin

Becoming a father has changed my life every day since it happened. Some sorrow, some grief, and some expense—but such joy, such love, and such excitement my three wonderful children have brought me. And it's not over yet. Each age we pass through brings new joys and experiences, of which the vast majority are extremely loving and rewarding.

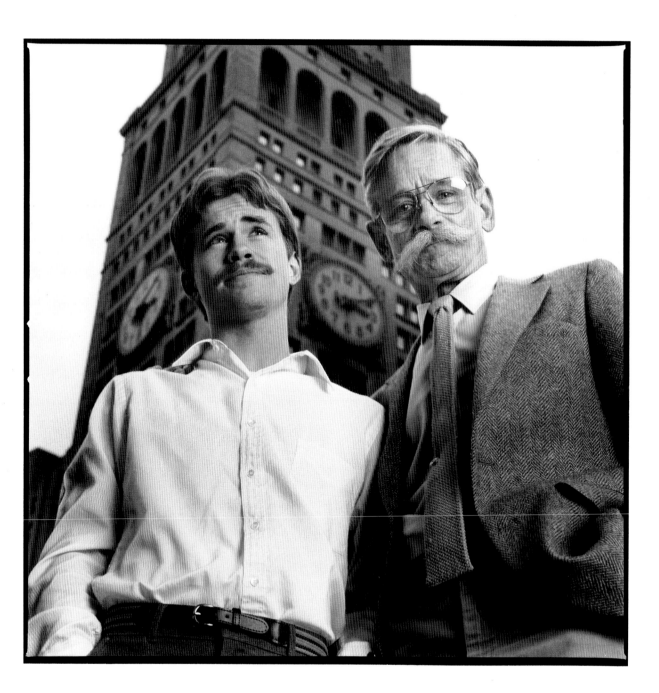

Julius Erving

former Philadelphia 76er, with

Jay, Cory, *and* Cheo

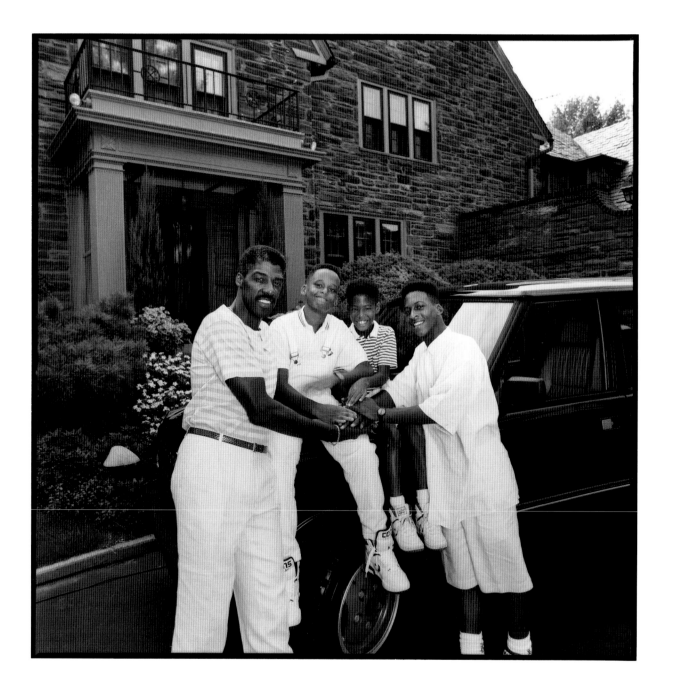

Bud Stillman

photographer and retired educator, with

Joseph *and grandsons*
Eli *and* Joseph

I became a single parent in the 1950s, with custody of my son. For me, the change was a vast improvement. Instead of reporting for The Berkshire Eagle *in Massachusetts, I taught 10th through 12th grades at Elisabeth Irwin in Greenwich Village. The same lousy pay, but so much more varied and far more absorbing—with three-month vacations.*

Joe went to Dalton. In those days parking a car was a cinch. I threw blankets over the sheets before driving us to school, and when I got home I did the two dishes. The cuisine was unsophisticated in our railroad flat. Cutting up bananas and grapefruit and cooking frozen peas and hamburger was not a chore, and the machine washed our clothes. Drying them on a clothesline strung from pulleys on our fire escape was dynamite. Joey handled the wooden clothespins, strengthen-ing his fingers. On weekends we sometimes visited people in the country.

Sitting in the park was terrific. The other mothers gave me a thousand tips on how to bring up my boy. Busy, busy, those days and nights. Most of all, I enjoyed reading to him after supper; he seemed so vivid, so astonishingly responsive. My students became his claque. For the first three months after his mother left, he went to sleep in the little room next to mine, listening to Chopin's nocturnes. I thought I had a little Ignace Paderewski. And he got to sleep so quickly, his last remarks drifting through the chords. When I remarried in 1959 we had become so companionable that we were both shocked by the change. Now Joe has a wife of his own and two sons. Last night we had frozen peas and hamburger in their apartment.

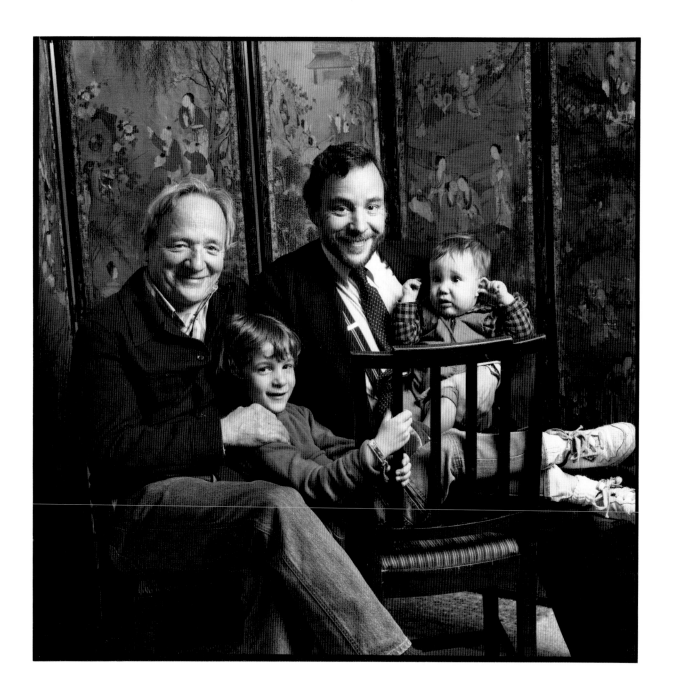

Adolph Green

Tony Award-winning writer and
lyricist, with

Adam

I became a father to Adam (three years later came my daughter, Amanda) rather late in my career. Phyllis Newman—a beautiful, talented, and hilariously funny girl, some twenty years my junior—and I were married in 1960, and Adam followed about a year later. I found myself in my mid forties, suddenly feeling and behaving like Harold Teen at a time when most folks are sober and mature citizens. I have continued feeling that way ever since, as my entire family will attest. Adam is definitely my senior advisor in many matters of decision and adult responsibility. I keep watching him and his sister blossom in astonishing, continuously surprising social and creative ways.

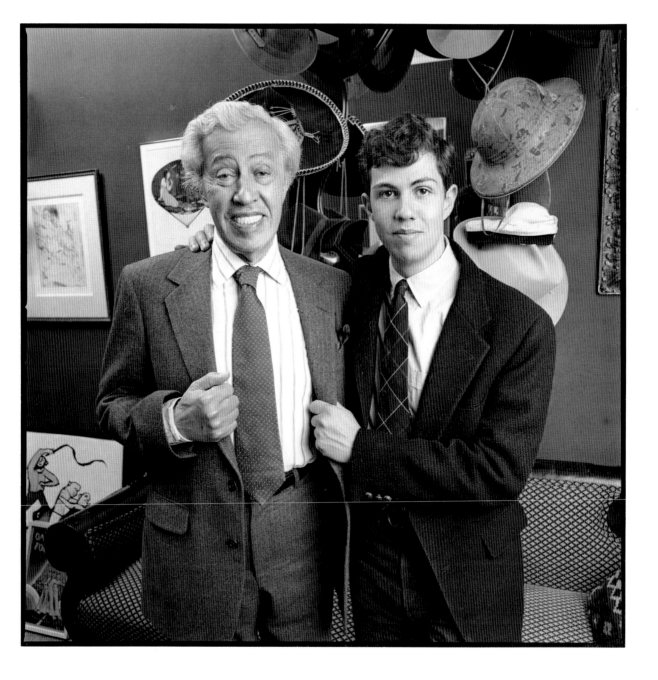

Tom Wesselmann

artist, with

Lane

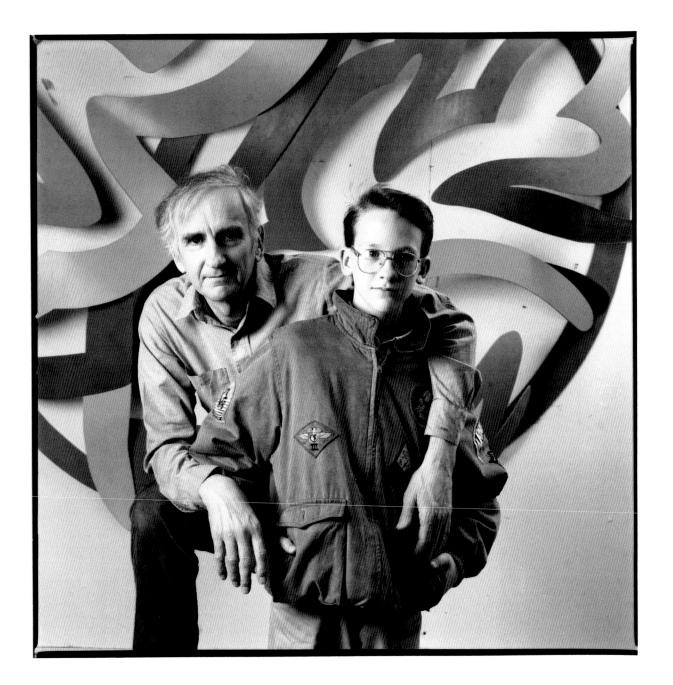

Chellis French

retired insurance executive, with

Andrew

Becoming a father changed my life completely. I was no longer one half of a couple. I was now a "family man." I was one of the brotherhood of fathers and accepted in a new way by them in the shop and office or wherever I might be. There was not just a change in status, but an invisible change in stature. I had grown six inches taller but no one else knew it. It was as though I had really accomplished something on my own instead of just participating in the oldest miracle known to mankind. And that was just the beginning.

Before our first child was born I determined that I would not be just "a traditional American father." By that I meant I wanted to be an active partner, sharing in the care of that child. I wanted there to be a togetherness, a togetherness of the father with the family I felt was missing in too many cases. I think this desire came partly because I never felt really close to my own father. I always thought that he regretted this as much as I did but that he didn't quite know what to do about it; I didn't, either.

So I have tried during the years to be there as a nurturing parent and not just as a provider. I feel Andy and I have maintained a close relationship, and I hope he feels that way, too.

When I was born, I became a son. When a child was born from me, I became a father as well as being a son. And that made all the difference.

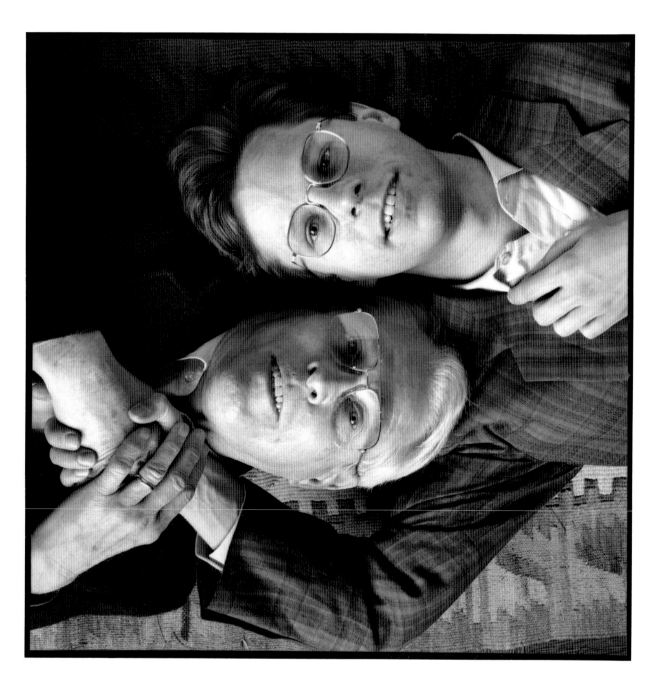

Louis Golic

building inspector, with

Greg, Bob *(Browns nose tackle), and*
Mike *(Eagles defensive tackle)*

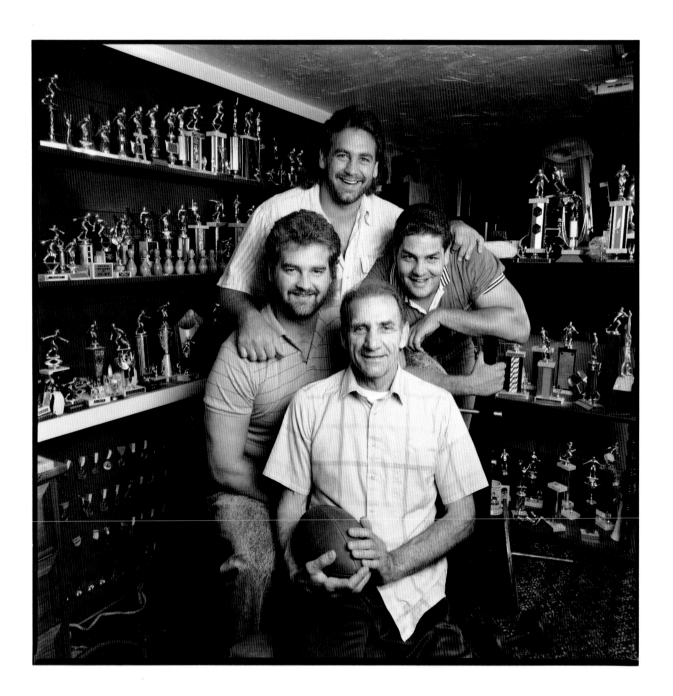

Harold Prince

Tony Award-winning Broadway producer and director, with

Charles

I suppose it's not uncommon to be obsessive about the work you love to do. It starts out you're looking over a fence at people who are doing that work, and you're hoping there will be a place for you. You climb the fence, you become one of those people, and, as the years go on, you become—if you're lucky—secure in a reputation as one of them. Still, you worry about the next assignment, about its reception, about keeping current and vital.

And then you have children. As they grow older—because they, too, have a dream, and energy, and talent—you transfer the apprehension, the obsessiveness to their careers. And your own needs are less urgent, less stressful.

At this moment in time, I'm enjoying Charley and Daisy Prince's careers, just as I enjoyed my own. Which is fine.

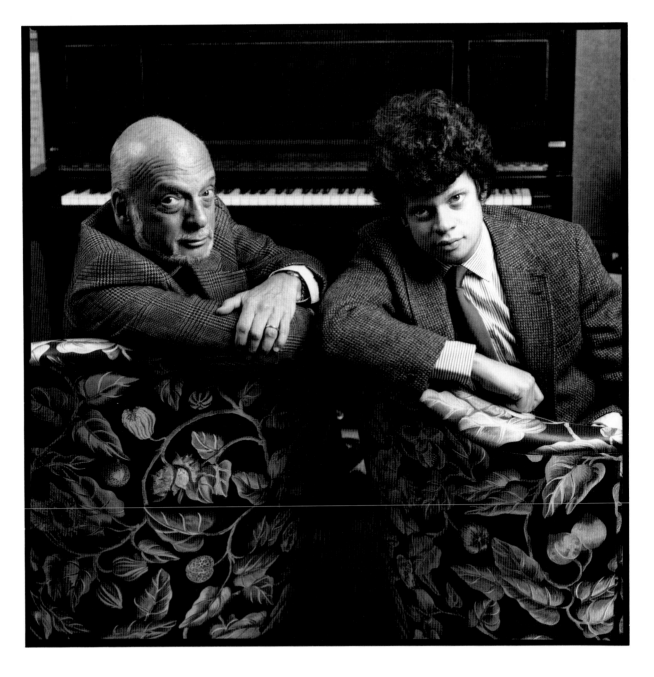

Fred Schmidt

metal sculptor, with

Ethan

Ethan arrived, bringing new and old dimensions into my life. At forty-four, I had forgotten the sounds and smells of a baby. I remember being afraid of allowing myself totally to love him, for fear of somehow losing him. The fear will always be there, but my heart has long since taken the leap. Becoming Ethan's father has liberated me.

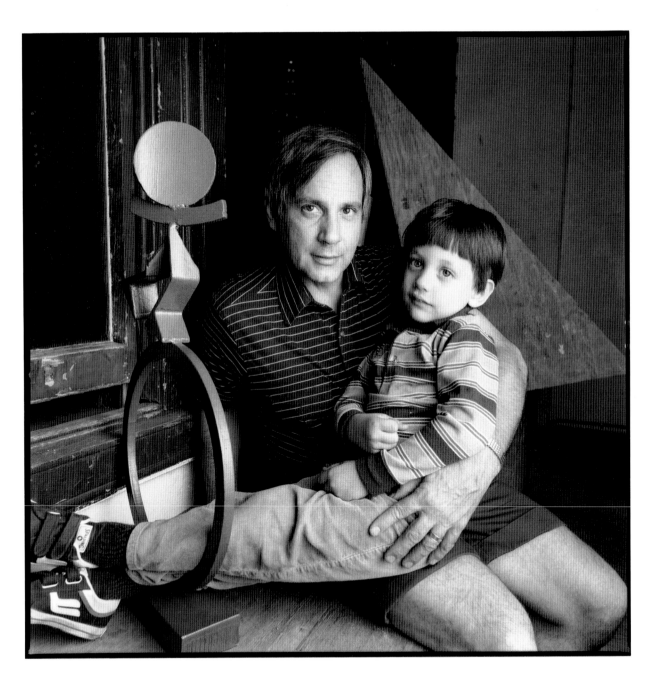

Robert E. Abrams

publisher, with

Josh, Ben, *and* Dan

Fatherhood, I am learning, is an attitude of availability, an unhesitating willingness to nurture, protect, and guide that certainly extends to daughters as well as sons. Fatherhood in its fullest expression is a type of love and concern that goes beyond the nuclear family and projects into the world. Although, as a man and a father, I share a sex-linked destiny with my sons (both in potential and limitations) that I cannot share with my daughter, that destiny is inextricably entwined and created with women, who are—or one day will be—mothers.

I think that's terrific!

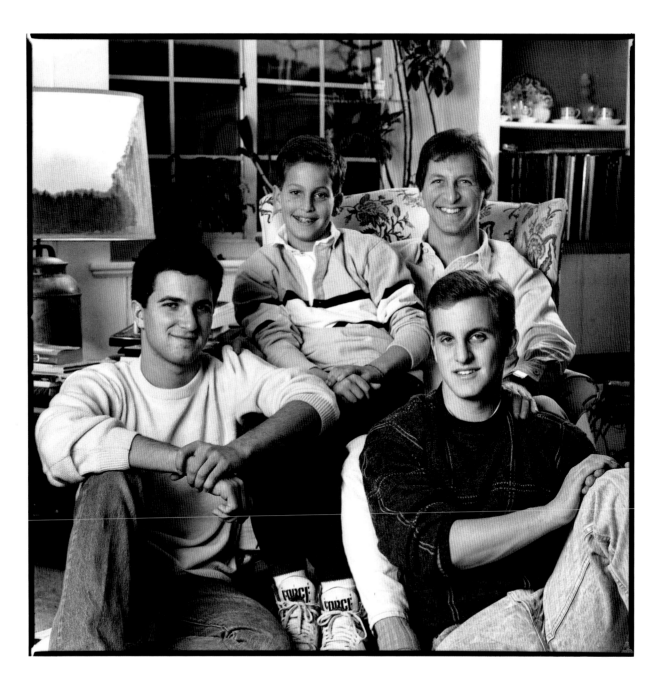

Eli Wallach

film and television actor, with

Peter

How did fatherhood change my life? I didn't think about such a lofty thought when I became a father. Now, however, I feel it completes the circle. I hope my children will enrich their own and other people's lives by their work. Certainly, they've fulfilled mine.

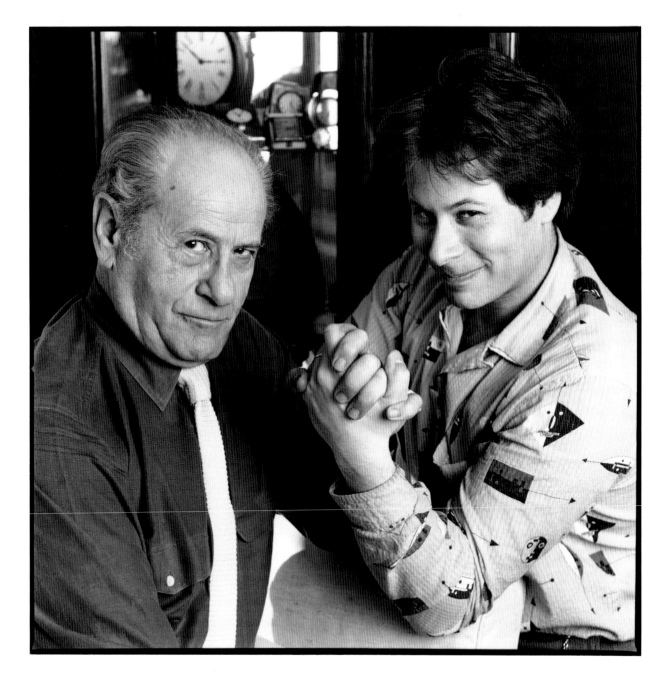

Bruce Yonemoto

video artist, with

Troy

I sometimes think that I exist in a reality of reruns, and that the future can never be better than the past. But every time I hold Troy, I realize that the real is a relation like any other and the essence of things is by no means linked to their reality. When I look into his eyes and see him staring at something beyond my gaze, Troy helps me to realize that there are other relations, besides reality, that the mind is capable of grasping, and that are also primary, like chance, illusion, the fantastic, the dream.

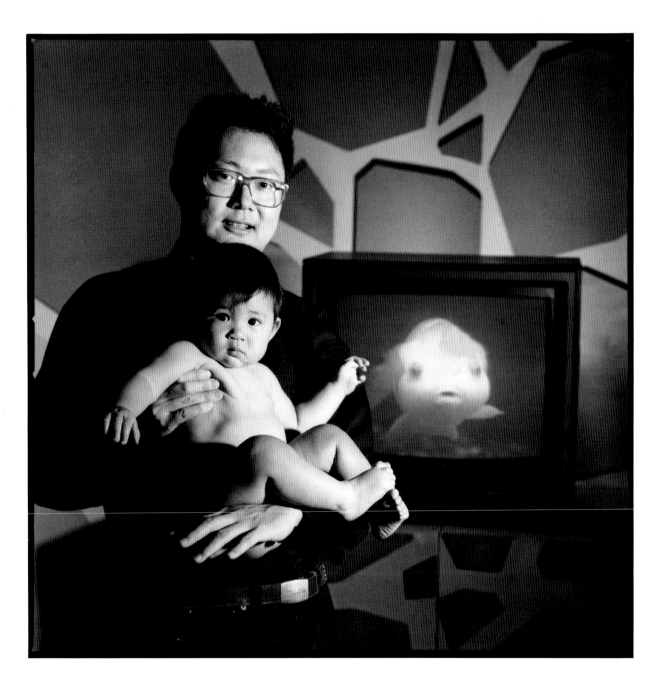

Charles Gaines

writer and sportsman, with

Latham *and* Shelby

Becoming a father didn't change my life so much as make it: I had very little in life that I cared about before I began fathering children at twenty-one. And without those children—my two boys and my daughter, Greta—there would be very little in life now that I care about. To paraphrase Vince Lombardi: for me, fatherhood hasn't been the main thing, it's been the only thing; and in it I found all the point to life I expect to find or need.

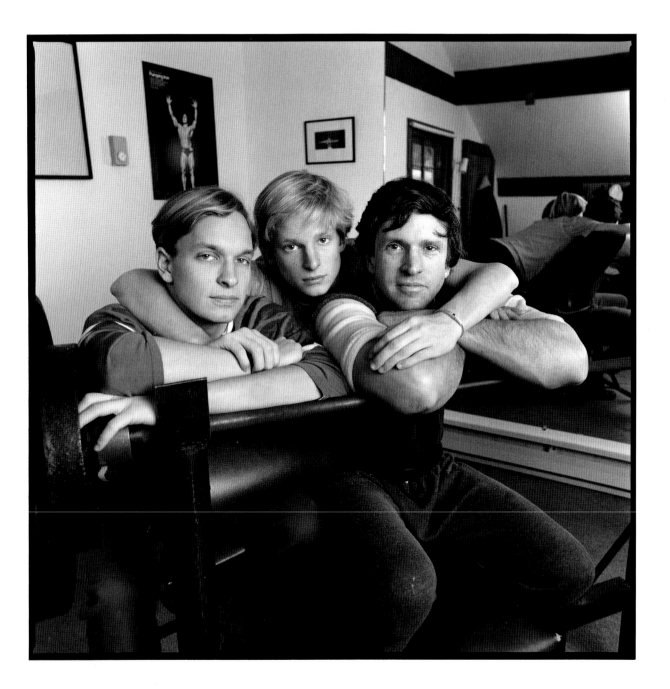

J. Reuben Silverbird

restaurateur and entertainer, with

Gil

For me fatherhood can be summed up in two simple words, love *and* responsibility.

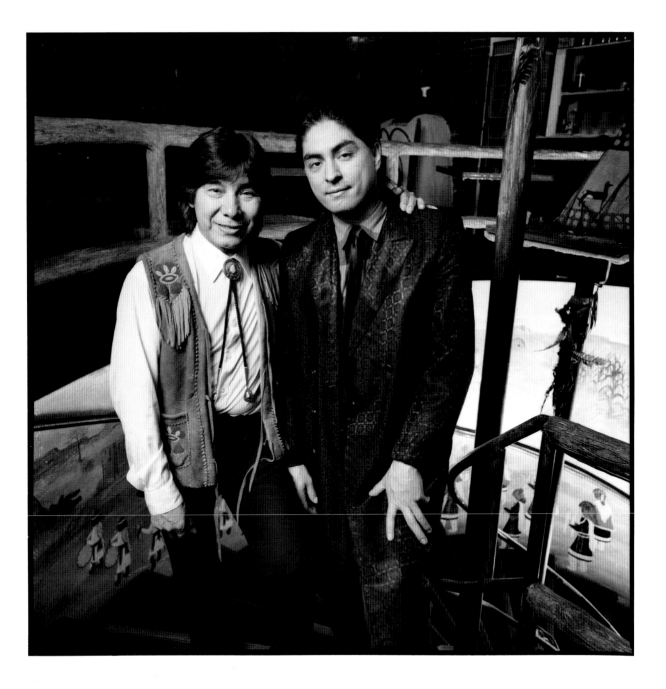

Sharpe James

mayor of Newark, New Jersey, with

Kevin *and* Elliott

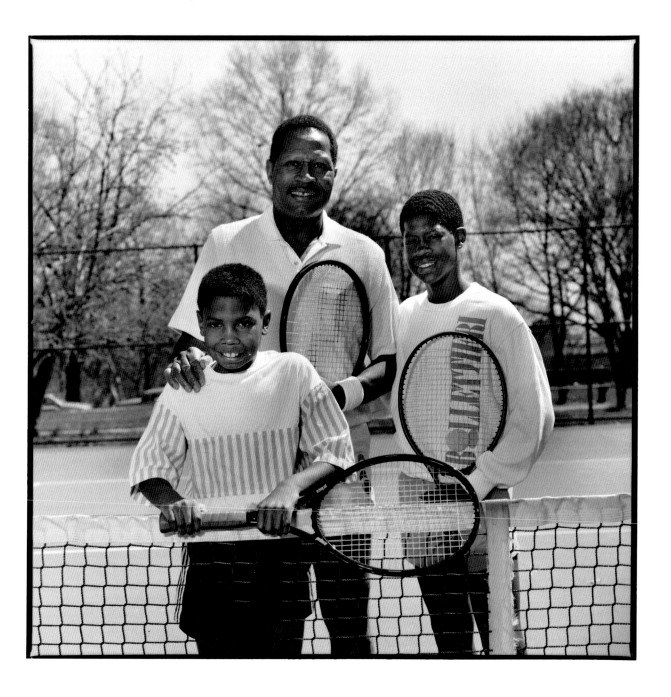

Mike Stoller

gold-record songwriter and composer, with

Peter *and* Adam

The scariest thing about being a father is hearing myself say things to my kids, the same things that I didn't understand when my father used to say them to me. It's an eerie kind of delayed echo that rings in my ears. It's of no benefit to Peter, Adam, or my daughter, Amy, since they don't hear it, but it has helped me to understand my father much better.

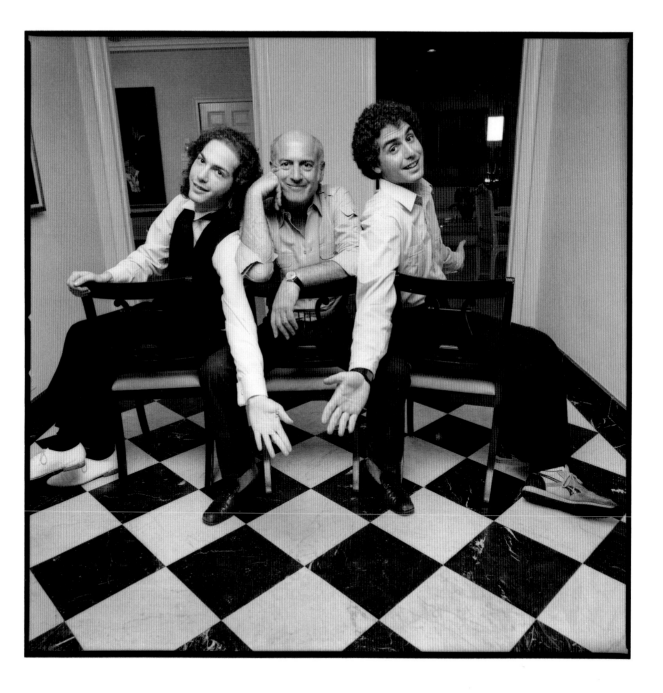

Dave Brubeck

jazz musician and composer, with

Darius, Matthew, Chris, Michael, *and* Daniel

How did becoming a father change my life? The first thought that comes to mind is an overwhelming sense of responsibility. Love, the most important emotion, I must confess, came second. An unqualified, selfless, parental love expects nothing in return except an enjoyment of the child itself. The next word that came to mind was individuality. *It is incredible to me how each child could be so uniquely himself, from the moment of birth.*

When the entire family is reunited, I enjoy watching the interaction among those individuals. Now that they are grown to adulthood and experienced—along with pride and love—I feel a great sense of fulfillment.

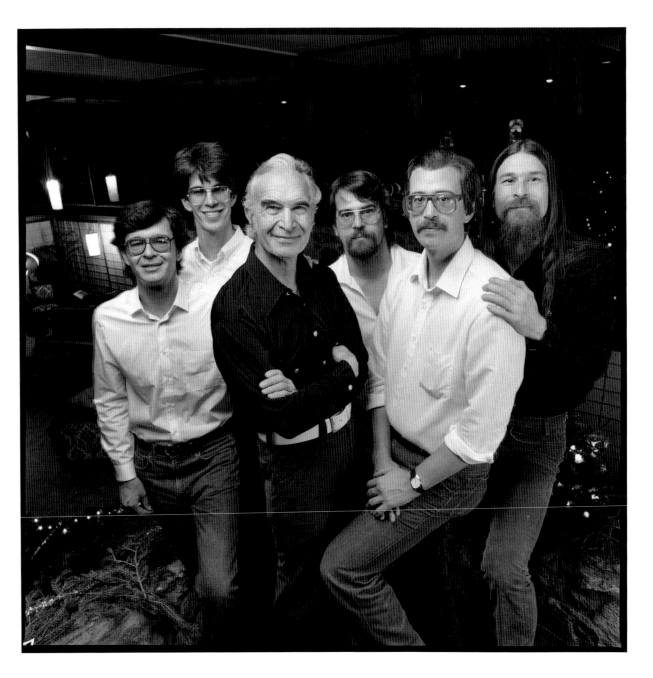

Joseph Bologna

actor, director, writer, with

Gabriel

From the moment you look at him in his basinet and you have the horrifying realization that you are no longer the kid he is, to the day you stare at a tall feller with a deep voice and say to yourself, "My God, the guy's a grown grown-up!"; from "Da-da, hold my hand," to "Daddy, what do you say we play a little catch?" to "Dad, I need you to help me figure out this differential equation," to "We don't do it that way anymore, pop" (which seems to be happening younger and younger), your life is completely altered by inescapable responsibilities, everyday activities, visceral pains, prodigious joys, and a profound bond of love. Without that experience of fatherhood, there would be a monumental gap in the ages of man.

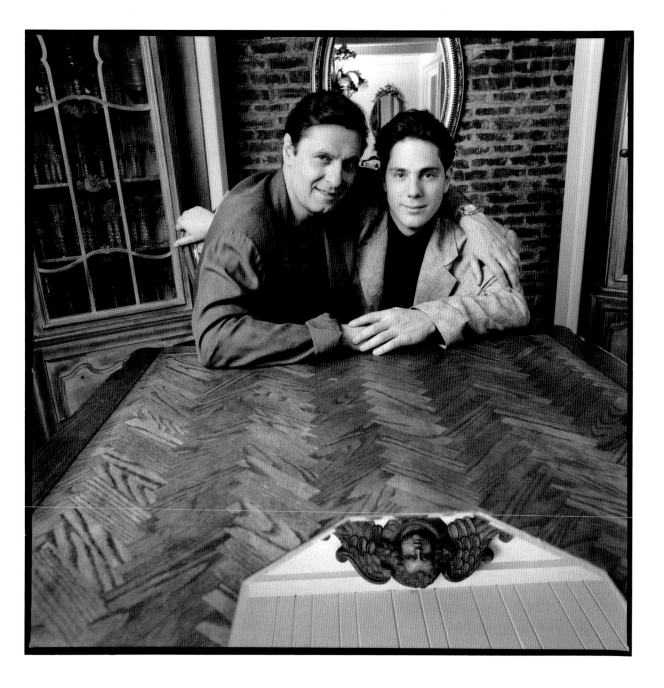

Kurt Weihs

advertising art director, with

Tommy *and grandson* **Kristian**

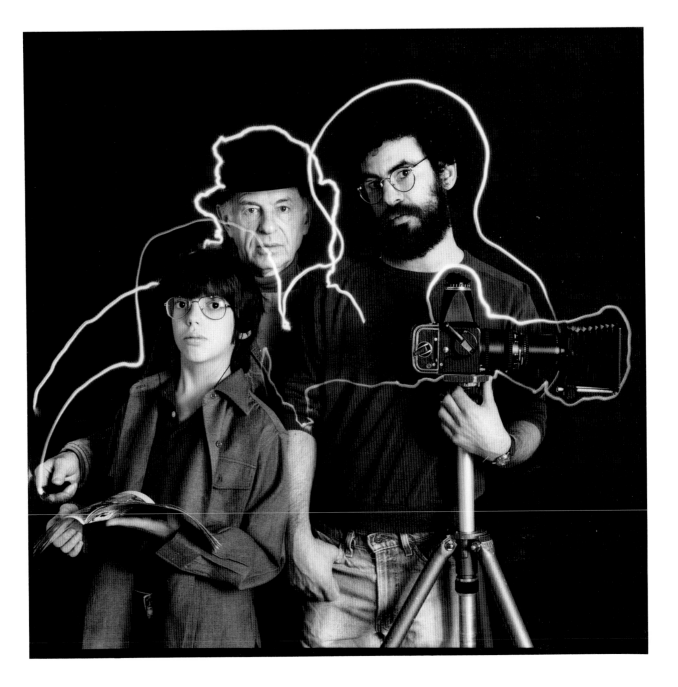

Rospo Pallenberg

screenwriter and director, with

Harry

I finally started growing up with him. At times, I think he's gotten ahead of me. He sure thinks so.

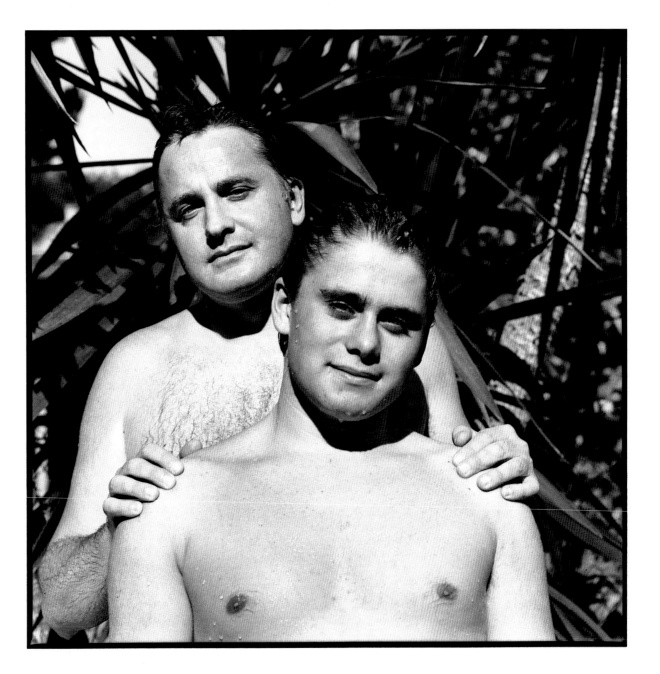

Paul Fisher

engineer, with

James *and grandson* **James, Jr.**

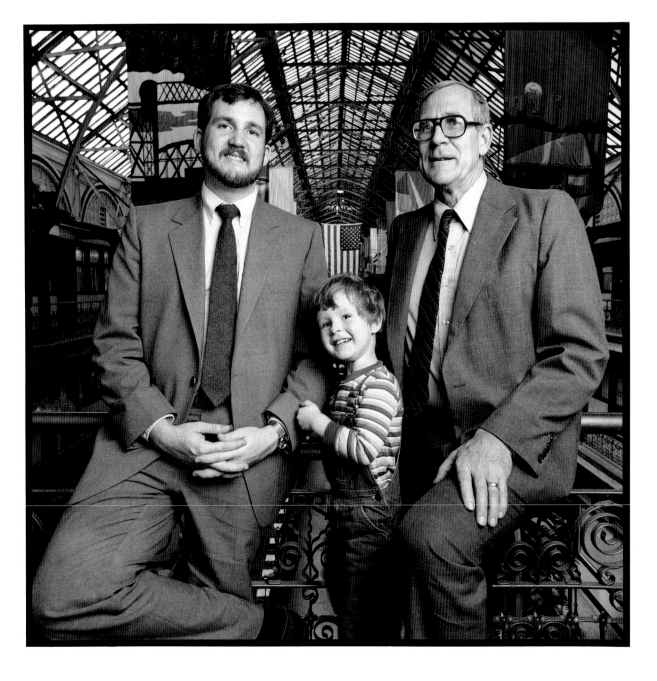

Thomas P. (Tip) O'Neil, Jr.

former Speaker of the United States House of Representatives, with

Thomas III *and grandson*
Thomas IV

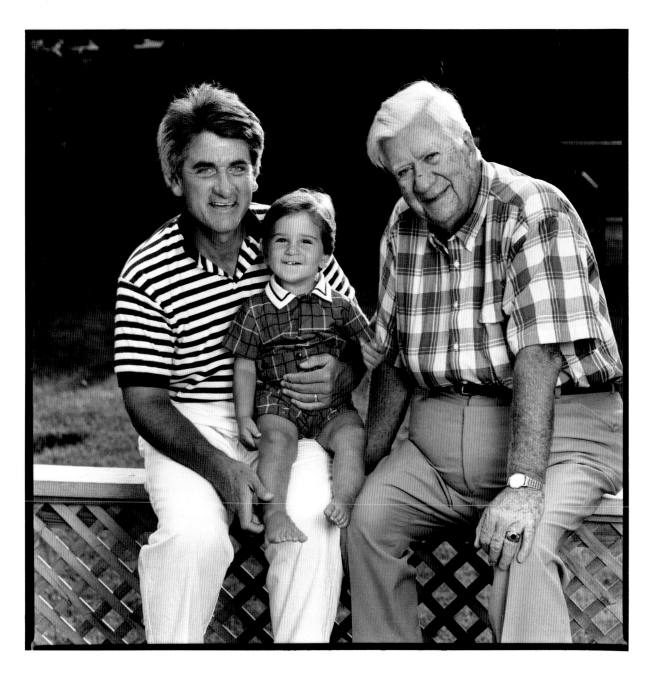

Dee Snider

rock musician, with

Jesse

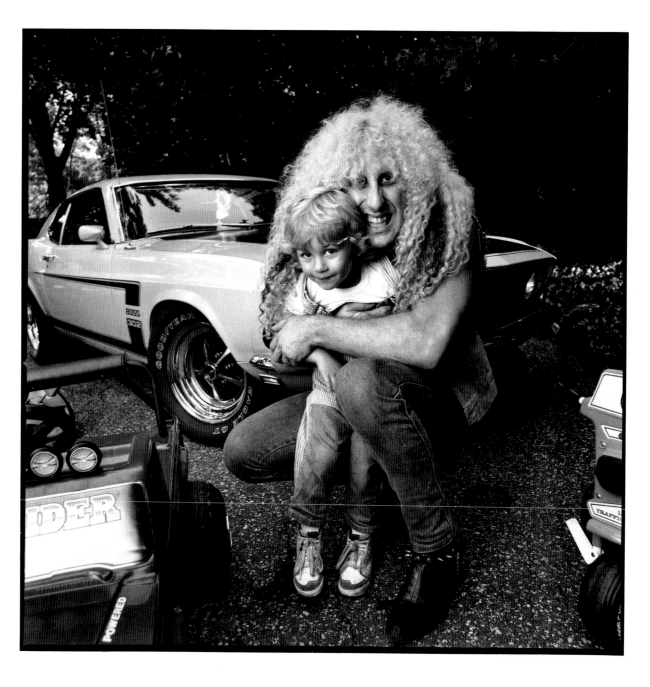

Benny Andrews

artist, with

Thomas and Christopher

As a child, I'd dream of having two boys to travel around the world with me on trips of adventure. As an adult, I realized that my two boys had ideas of their own about seeking out adventure. Now we share our individual adventures as equals.

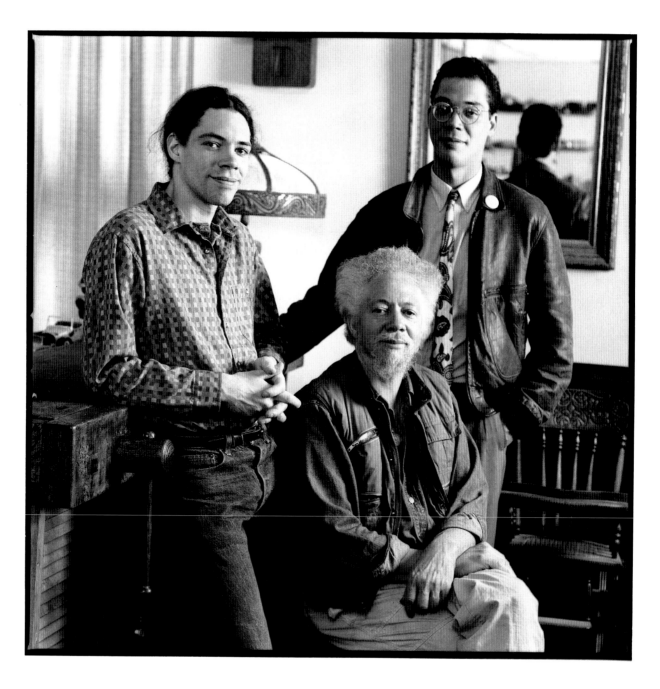

Peter Davis

documentary filmmaker and writer, with

Jesse *and* Nicholas

On July 3, 1963, my life changed so radically I seem only to have existed in twilight before then. That day my oldest son (who unfortunately was out of town when Steven Begleiter took the rest of us to the ballgame) came pounding and chuckling into the world. Along with his two younger brothers and (at last) a younger sister, he has let me know myself. The child may not be father so much as mirror to the man. Fatherhood enfolded, enriched, enlarged, ennobled my life in 1963 and has continued to do so every day in the quarter century since. I'm far too selfish to give my whole life to fatherhood, but fatherhood gives my life its tone.

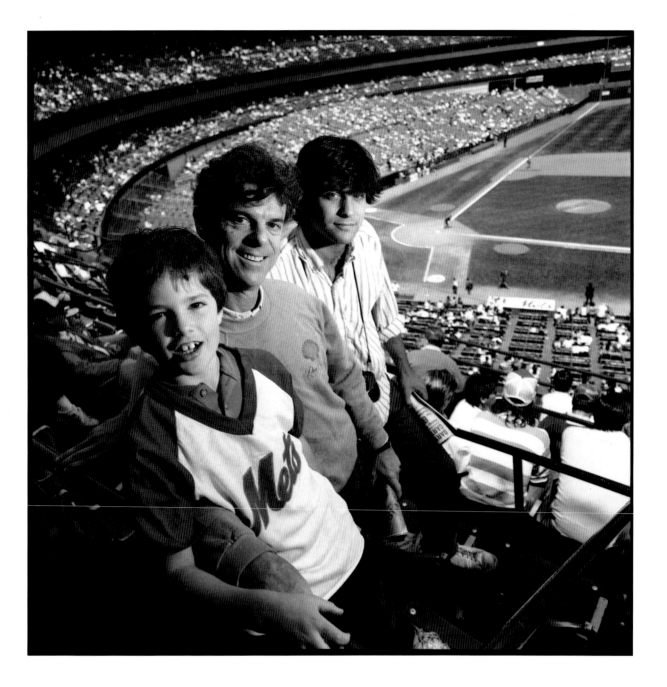

Paul Weller

retired commercial photographer, with

Michael, *playwright*

At the time that my son arrived my life was being changed by Uncle Sam, who celebrated the occasion by shipping me off to Africa, India, Burma, and China for three years. I had just had time to learn about changing diapers. I was good at my part, and he was good at his. From day one he was good at everything. He sort of set me an example. I knew I had a kid, but when I got back to the States I also had a new friend—no sweat. It's been that way ever since, and I recommend it!

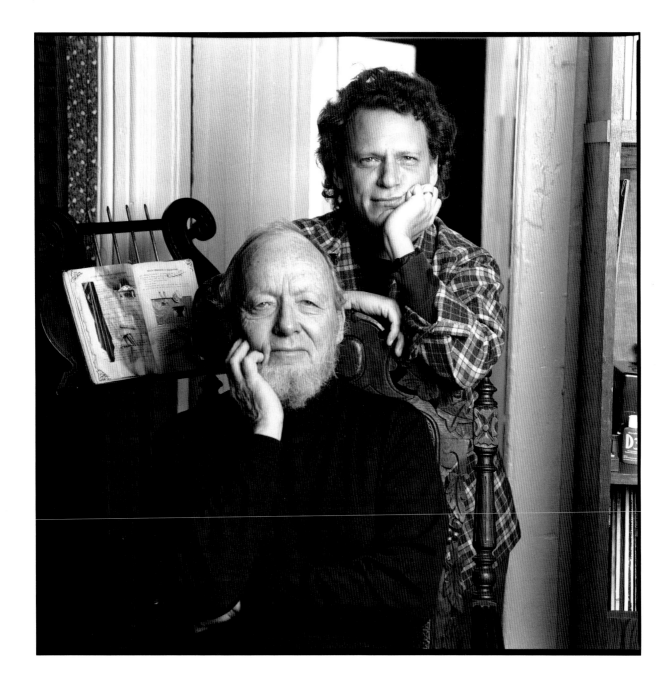

Peter Barton

filmmaker, with

Jesse

Your cry yanks me so fast
Out of my bed
My dreams come apart
And make the rug slippery
My lungs get so small
From drawing my biceps
Tight to my ribs
To scoop you up
With anger and joy
That they ache to my shoulders.

My eyes get so busy
Awaiting your smile
That my mouth forgets
And my nose is becalmed.

I shush up a storm
Whispering the dark
If only my woosh
Sounds enough like your mother's
I'll carry you far
Out to sea with my sighs
And when we're to port
Bobbing still among your toys
I'll ease you down
And, windlassing my back up,
Take in such a feathered breath
That it wakes the whole house.

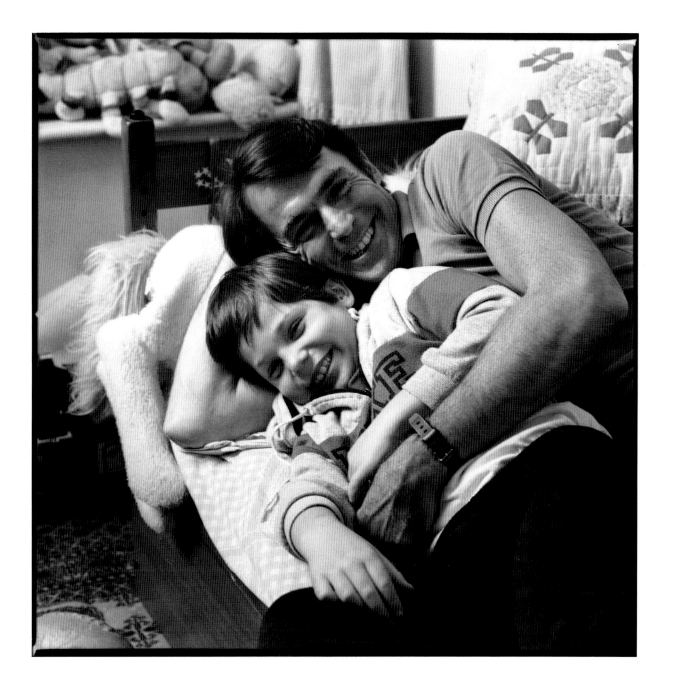

Tommy John, Jr.

pitcher, New York Yankees, with

Tommy III, Taylor, *and* Travis

What I try to be at home is not Tommy John, the Yankee pitcher, not the celebrity, but Tommy John, father of my three sons, doing regular things with them like going to see Bruce Springsteen in concert or attending school functions. I take my sons along to practice at Yankee Stadium, and they hit and throw and work out with me. It gives them a chance to be with Dad, which is vitally important, because I'm away so much during the baseball season. They love what I do and come to all my games when we play in town, even on school nights. I enjoy pitching with them watching.

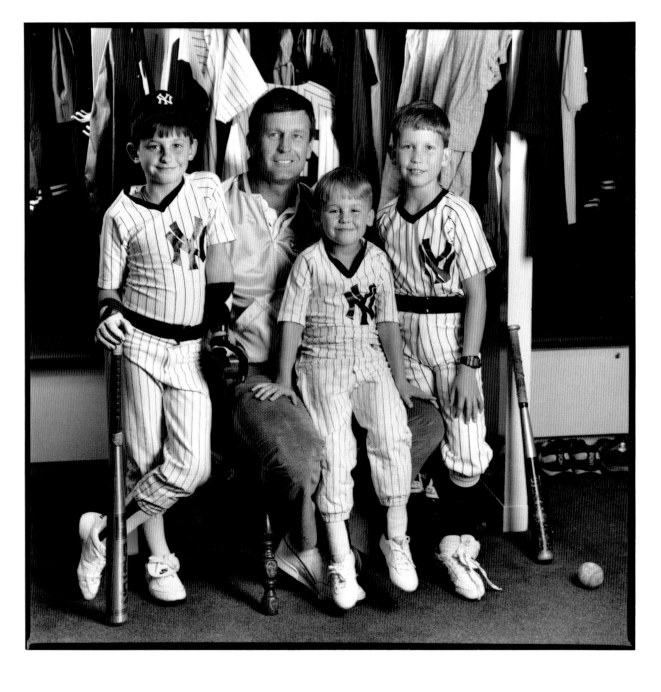

Joe Clark

principal, East Side High, Paterson, New Jersey, with

J. J.

I've always given entirely of myself to my son, J. J., and from the process of raising him and being a father I've learned a lot. I believe that you should do something for your children that wasn't done for you, and likewise they should do the same thing for their kids. They're our future, and, therefore, we have to teach them well and raise them well. I've tried to instill in my son four ingredients for success: courage, will, pertinacity, and skill. There's no such thing as luck, especially in today's obstacle-strewn world. Kids need discipline and direction in order to succeed.

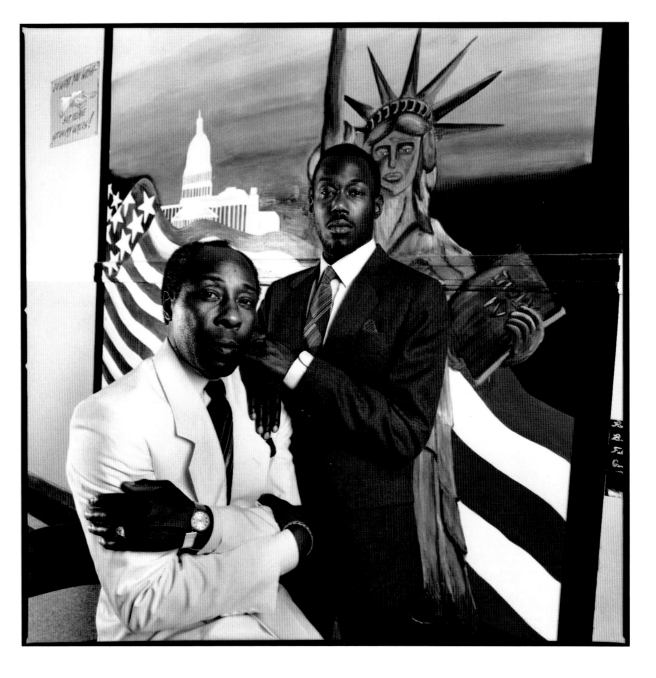

Harry P. Bitel

sod farmer, with

Harry J., Denis, *and grandson* Chad

I can't remember everything after sixty-five years, but it is great to be a father. Our daughter, Charlotte, was born in 1947. We were so proud and happy! Six years later, our son Harry John was born. What a joy and privilege to have a son! I was truly blessed. Two years later, our second son, Dennis Michael, was our third miracle of life.

I decided to keep the farm and purchased more acreage so they could possibly "live off the land" someday. I must have made the right decision because when they came of age to start helping, they were very happy to work beside me. I wouldn't trade all the wonderful experiences with my children as they have grown to adulthood. Another source of great happiness are my three grandsons and three granddaughters. They bring back the memories of rearing my own children. —Harry P. Bitel

The birth of our son, Chad Martin Bitel, gave me great pride and honor, as well as great satisfaction, like when my daughter, Jenny Lynn, was born. Chad reminds me so much of myself when I was small—his love of nature, the land, and machinery. The love of machinery is the highlight of his life. Chad loves to ride on it, be around it, look at it, and color pictures of it. It gives me great joy to be able to give him rides on all types of machinery, being in the equipment business as well as farming. It also makes us very close and brings back a lot of good memories of my childhood, when my father gave me rides on all the equipment. I could see the pride and joy it gave my father, and now I can pass that on to Chad.
—Harry J. Bitel

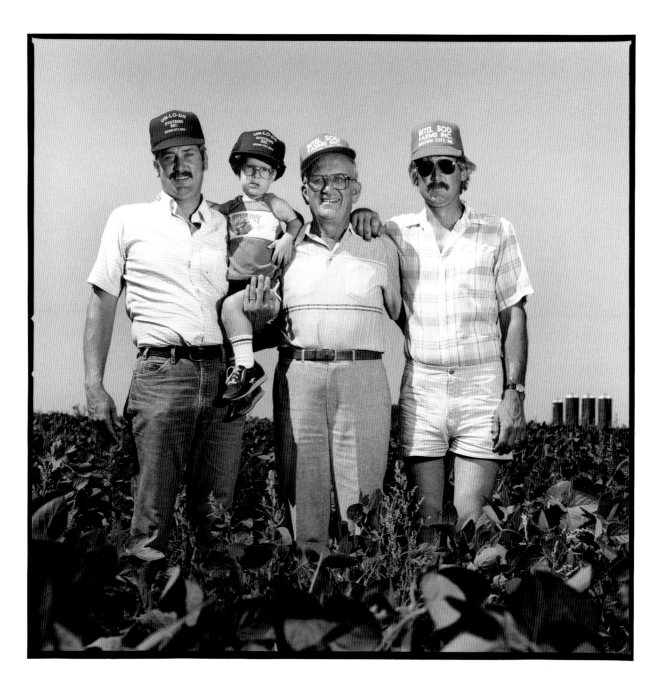

Philip Glass

composer, with

Zachary

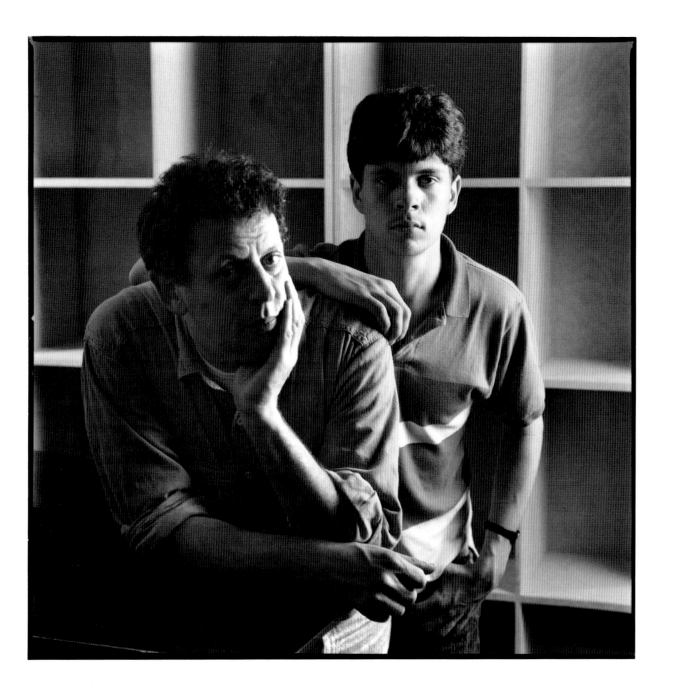

Joe Fox

senior editor, Random House, with

Elio, Jeffrey, Blair, Logan, *and* Michael

When my first four kids were young, I was a pretty poor excuse for a parent; I was simply too immature, too self-absorbed, too absent to be of much help to them or to enjoy the pleasures of fatherhood. Nevertheless, thanks in large part to my first wife and to their own strength, all of them have turned out well, and though there are some scars, they have largely forgiven me; they are generous young men.

When my fifth son was born I was fifty-nine, and I now have five grandchildren, four of whom are older than their uncle. At last I have grown up a little—at least enough to derive an enormous amount of pleasure from watching a young body grow and a young mind and vocabulary expand. It is wonderful to behold, but I feel sad when I realize how much I missed by not spending as much time with Logan, Jeffrey, Blair, and Michael as I now do with Elio.

How has becoming a parent again at this advanced age changed my life? The cliché one hears over and over is that "it keeps you young," but that's largely a fiction; though I don't change diapers in the middle of the night (Anne does), there's never enough time for sleep. What being a sixty-one-year-old father of a two-year-old does do is to make me less inflexible than I otherwise would be at my age, to make me more interested in my surroundings when I try to see them through the eyes of Elio, and to think and plan more about how to enjoy the ten or twenty years remaining of my life.

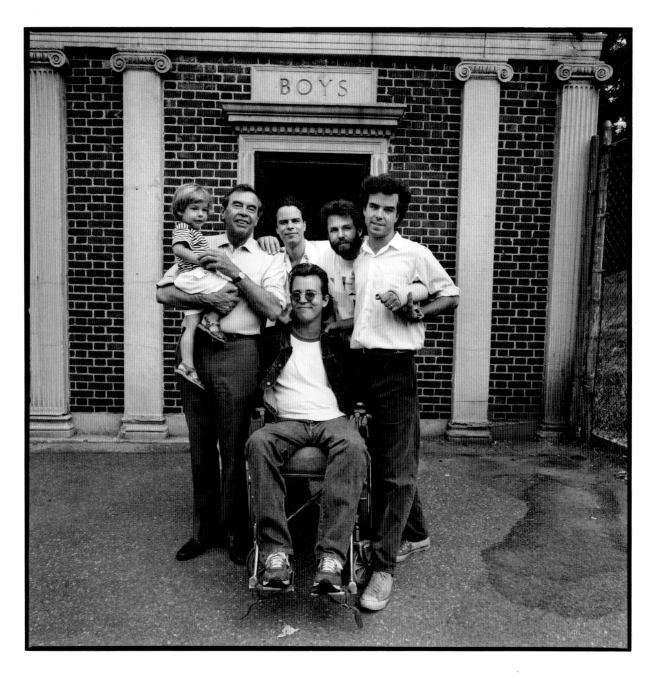

Bill Cosby

entertainer and author, with

Ennis

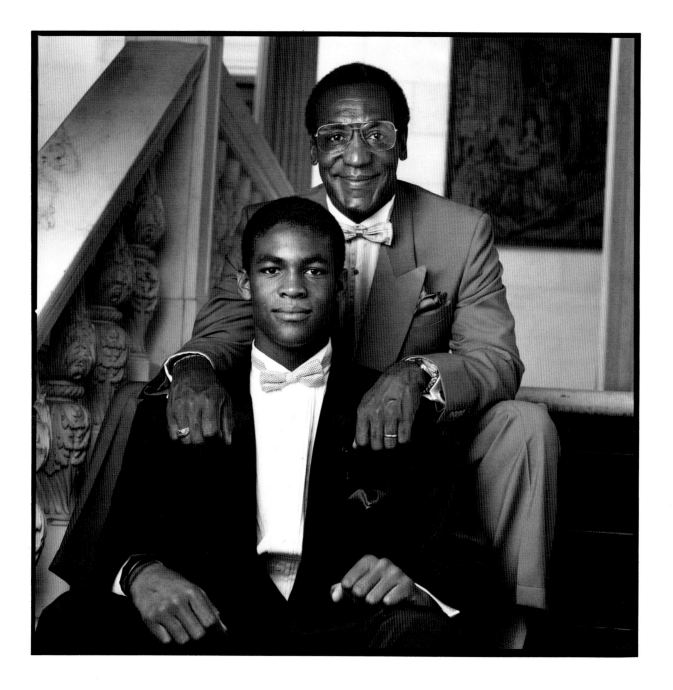

Marty Callner

video and film director, with

Dax *and* Chad

My experience with fatherhood really began when I took my two boys, at the ages of three and six, to raise on my own. I assured my ex-wife that things would work out fine.

Day One: We arrive at our new home in California from New York and decide to go out for a bite to eat. While driving down the street, I look to my right to find that my younger son, Chad, is no longer seated beside me. Looking into the rear-view mirror, I see that he is bouncing up the street behind me. I call my ex-wife and tell her that I'm not sure this is working out.

Fortunately, it did work out. My boys did a fine job of raising me.

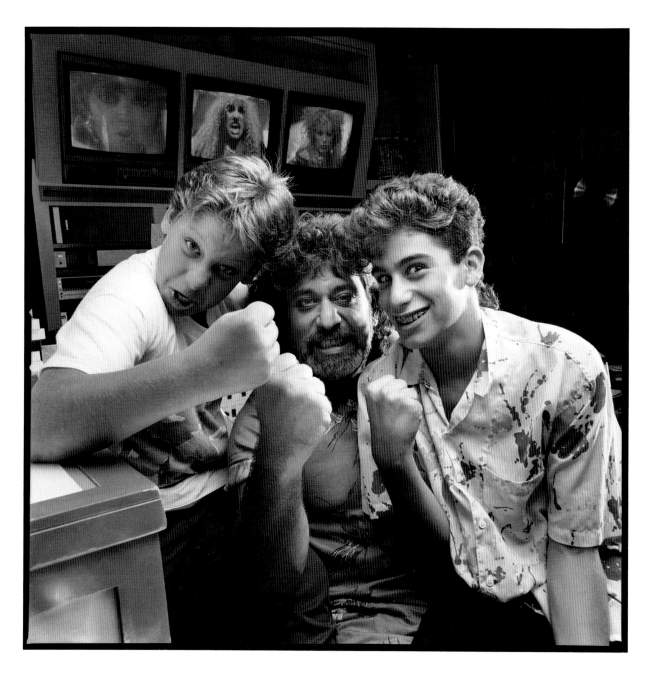

Henry Anatole Grunwald

U.S. Ambassador to Austria, former editor-in-chief, Time *magazine,* with

Peter

Fatherhood meant a new center to my life, and a blow against death— the death of my own parents a few years before Peter's birth. It meant awesome, new responsibilities, like answering questions (and more questions), acting as moral arbiter, and, most difficult of all, building treehouses. It meant an unending wave of love.

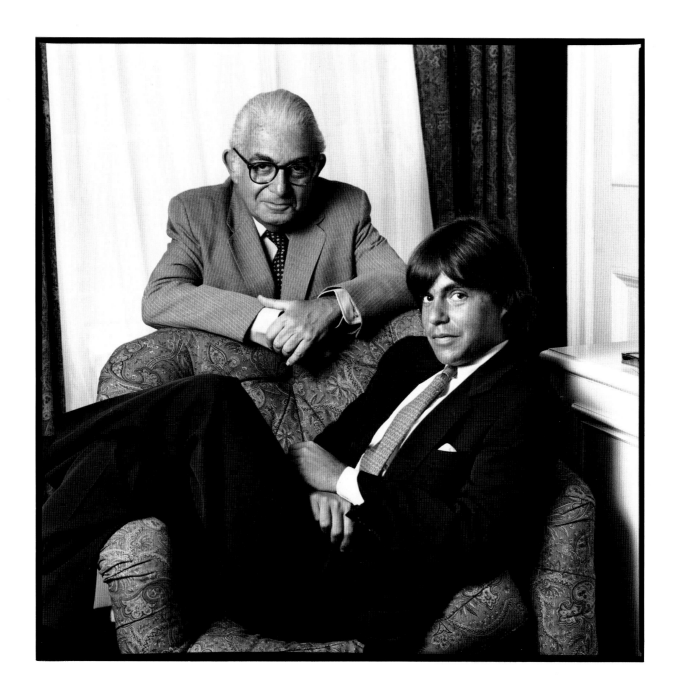

James Birch

curator, Cleveland Museum of Art, with

Sabastian

It amuses me to see Sabastian as a young man in his mid twenties, moving or reacting in exactly the same way he did at five years old. It pleases me to see myself in him, his voice, his hand movements, a way he walks that others see as "just like your father." But my greatest pleasure is in seeing him accomplish much more than I ever could.

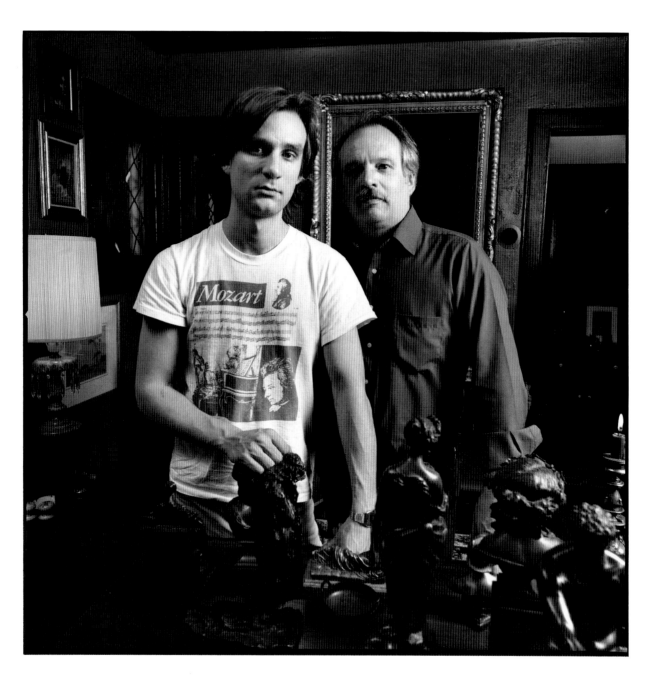

Reverend Albert Wagner

pastor, People Need People
House of God, with

Dwayne, Earl, *and* Craig

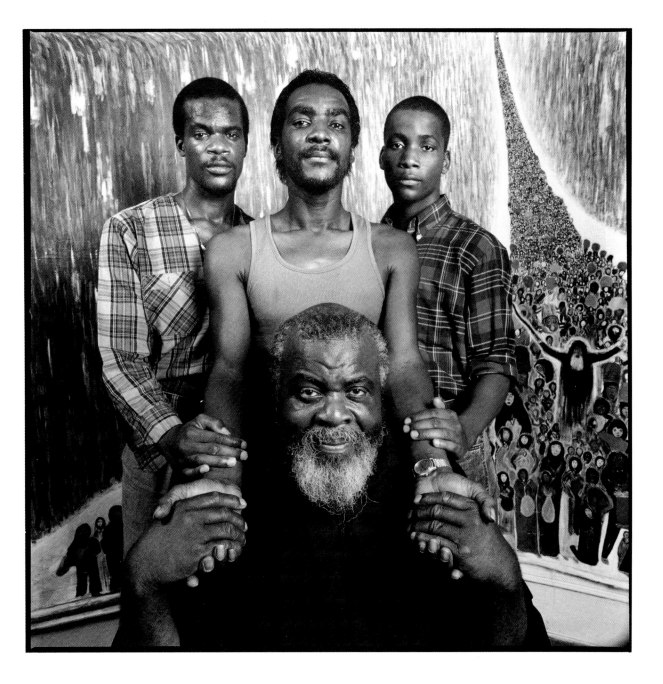

Wemselao Rivera

doorman, with

Bill *and grandson* **William**

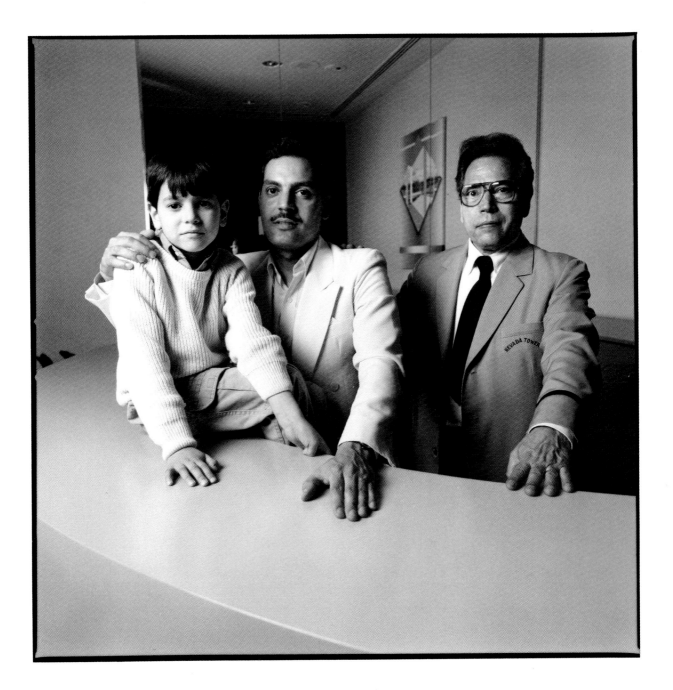

Murray Horwitz

composer, lyricist, and
former Barnum & Bailey clown, with

Alexander

Major changes brought by father-hood? Sleeplessness … conjunctivitis … ultimate meaning and purpose in life … more joy than had been believed possible … fewer first-run movies … less money.

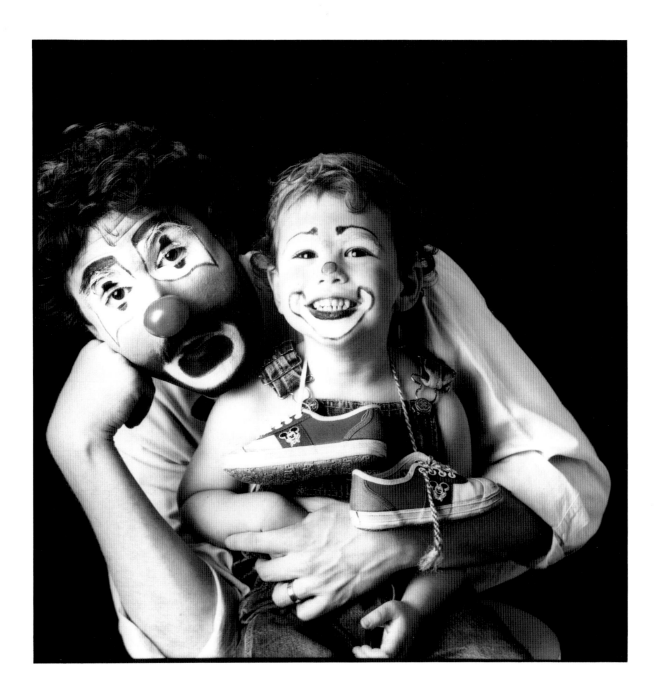

William E. Simon

entrepreneur and former U.S. Secretary of the Treasury, with

William E., Jr., *and* J. Peter

There is nothing more rewarding—or humbling—than fatherhood, and that is a lesson I have learned seven times over. I have discovered more of life and love from my children than I ever dreamed I could know.

My two sons were a glorious introduction to fatherhood. They were followed by five wonderful and lovely daughters. How lucky can one human being be!

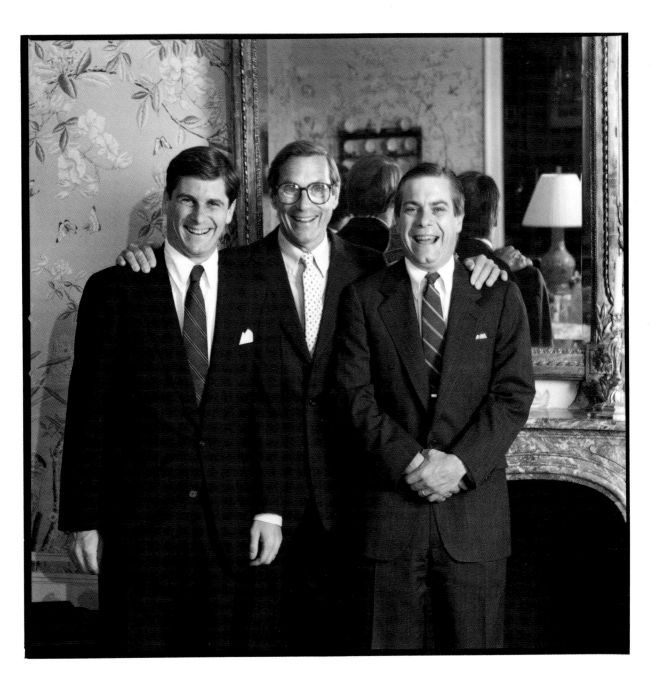

Peter Yarrow

songwriter and singer, with

Christopher

Parenthood: Now it counts to be the things you could be. Forgive yourself, too. They know if you love them.

He's fifteen now. He's the clock; the truth teller of me is his face, his gentleness, his caring—they go forward and we are a part, never again alone in this life.

He laughs easily and follows me as I ski cautiously down the mountain. This year he's making sure I'm okay. "You okay?" he asks from time to time. Yeah, I'm okay.

Fly, my son, fly. I love you.

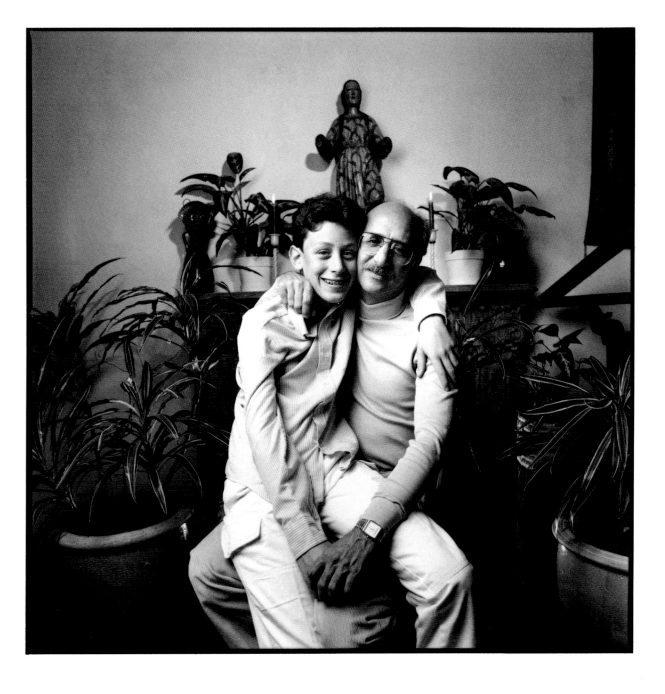

Sigi Hart

retired shirt manufacturer, with

Steve

Fatherhood became real the day Steve was born. The feeling never left me. My proudest moment was the day he wore his American Airlines uniform as first officer.

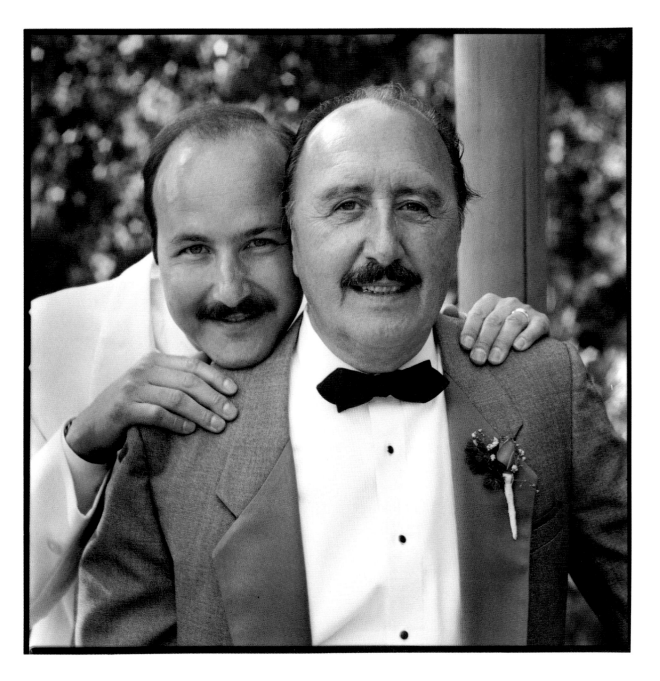

Tony Converse

television director, with

Xan *and* Tony, Jr.

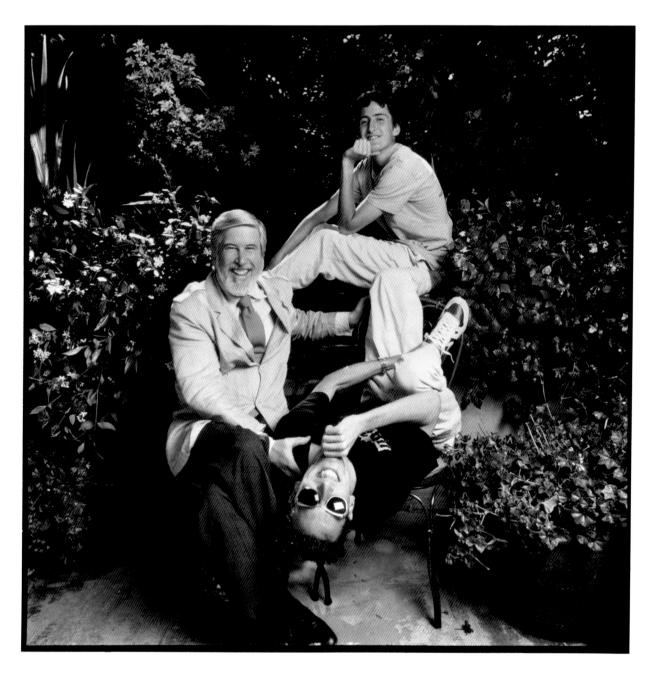

Ossie Davis

actor and playwright, with

Guy

My son needed a different kind of father than I needed. My parents had to teach me to survive in a racist, segregated society in Georgia. Many aspects of that training were negative. I had to learn how not to pass all of that on to him.

For example, I was working on a film in Shreveport, Louisiana, in 1968. It was a strong Klan community, and my son was there with me. On the set, the white kids and black kids would huddle together for warmth, and they shared bunking quarters; the Klan took objection. About that time, I had to fly back to New York for a day, and I gave my son, who was sixteen, the option of coming with me or staying. He chose to stay on his own and to face whatever danger might lie ahead. Everything worked out all right in the end, and, through him, I learned something about the fears I was raised with and how to deal with them realistically. He had taught me some elements of manhood that—for the sake of my own protection—had been denied me by my father.

After that occasion, I began to regard my son as a man I could respect and admire. He's learned a lot from me, but I've learned an equal amount from him.

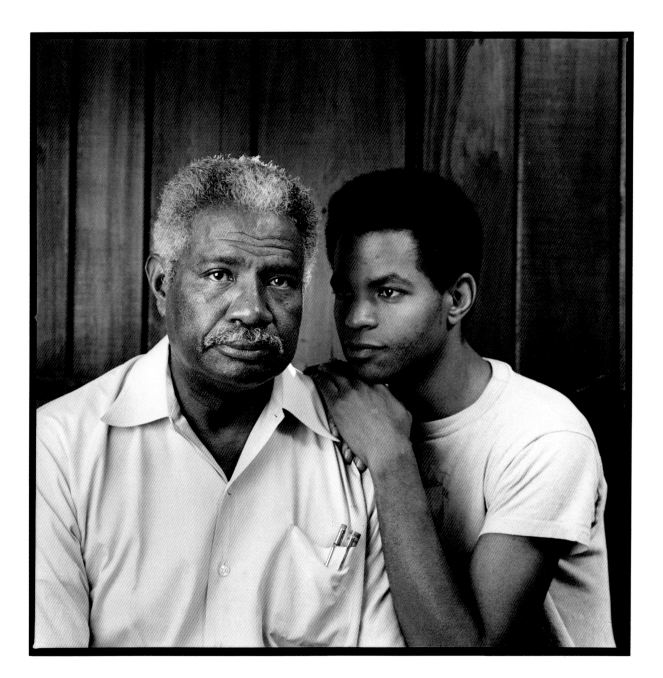

Joel Carmichael

author, with

L. David *and grandson* James

Men enthusiastically greet the birth of a boy because they think it demonstrates the continuity of their own identity. This is true if you're a king and need to perpetuate a dynasty, but, humanly speaking, the notion seems to me curiously misconceived.

In my own experience, the sight of one's newborn son does not confirm one's identity at all. That birth casts into orbit an utterly unpredictable being. Whatever similarities there may turn out to be between father and son, the son is unique—as, indeed, the father is. Communion is a stroke of luck. —Joel Carmichael

Being here between my father and my son, I am temporally and temperamentally in the middle as well. Having a father who has taught me throughout my life put me in touch with a past that, however palpable it seemed, is now gone. Being a father, I see in my son the person who will experience the unfolding future as it effaces the world I know. I wonder what my son will think when he is forty. —L. David Carmichael

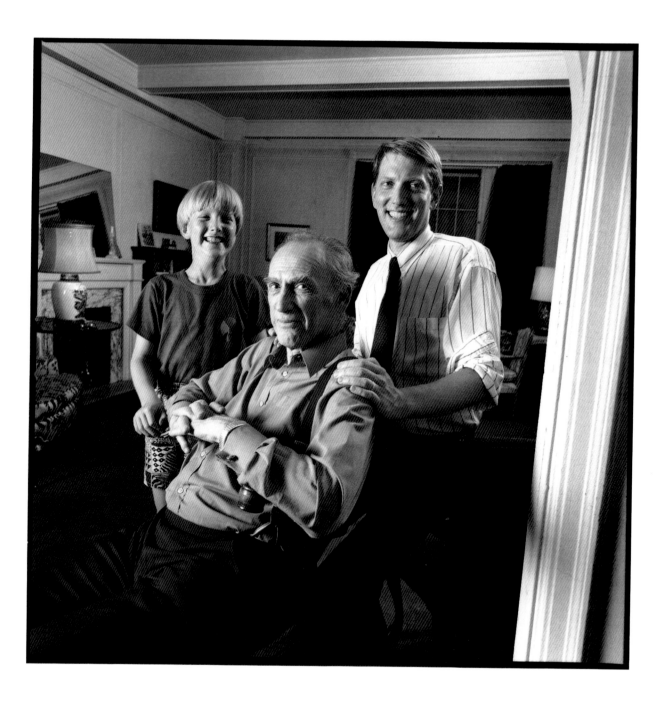

George Plimpton

writer, with

Taylor

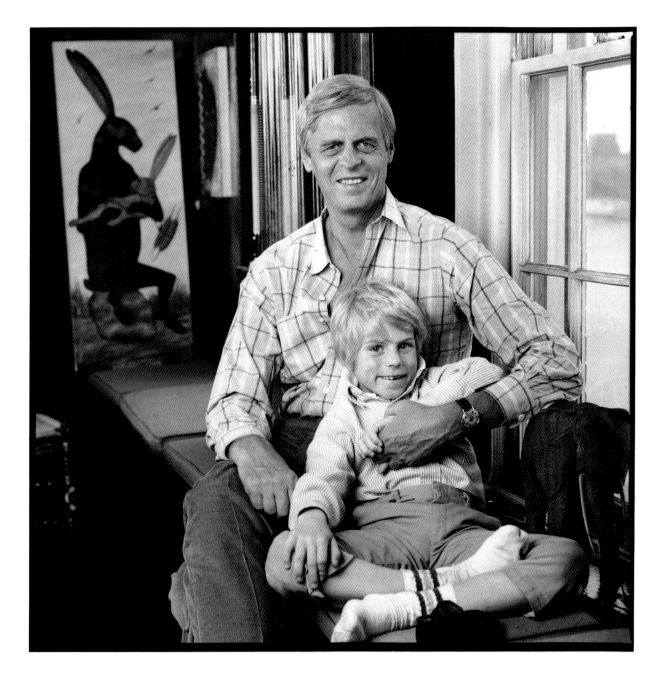

Kirk Douglas

actor, with

Eric

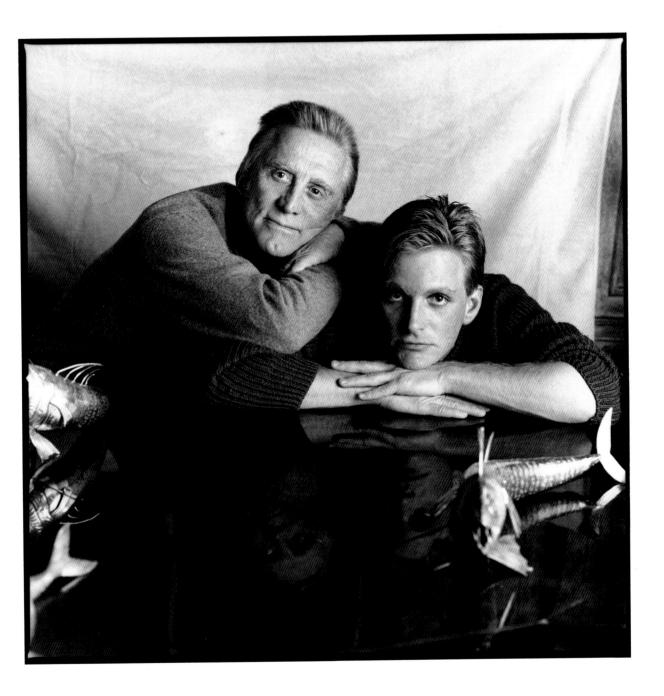

Stanley Gottlieb

entrepreneur, with

Adam *and* Sam

Becoming a father put me in awe of women, first of all. Specifically, of their ability to create life itself with the bare minimum (but essential) help from men. It has also been an ever-changing and ever-growing awareness of the miracle and divinity of the continuity of my genetic heritage, which is now within my children.

Having children has given me something outside my own personal self to "look on" for all the years of my life. It has been a binding tie and source of great mutual compassion and great caring between me and the greatest love of my life—my wife.

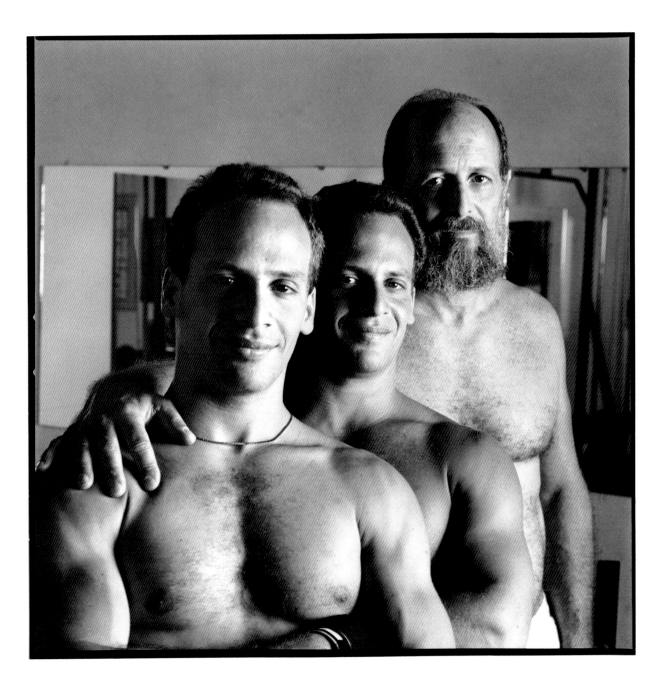

Larry Rivers

artist, with

Sam

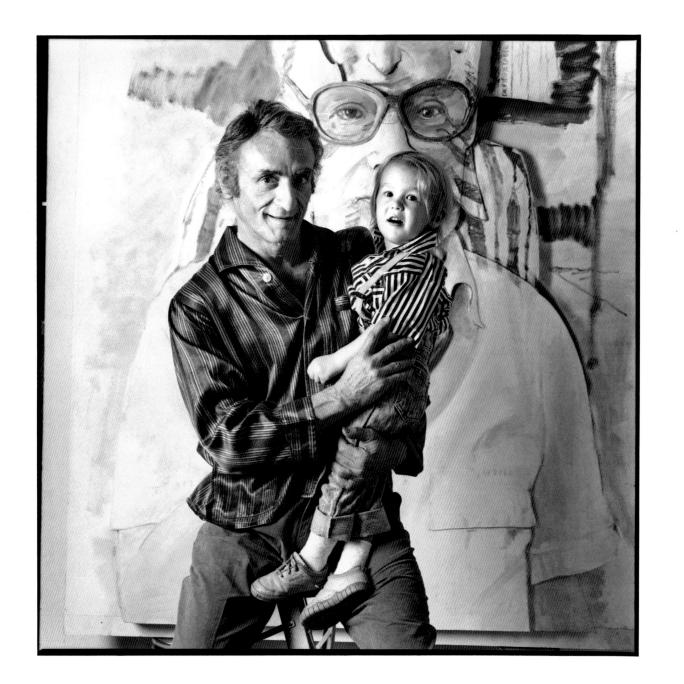

Jacob Slutzky, Ph.D.

psychoanalyst, with

Mitchell

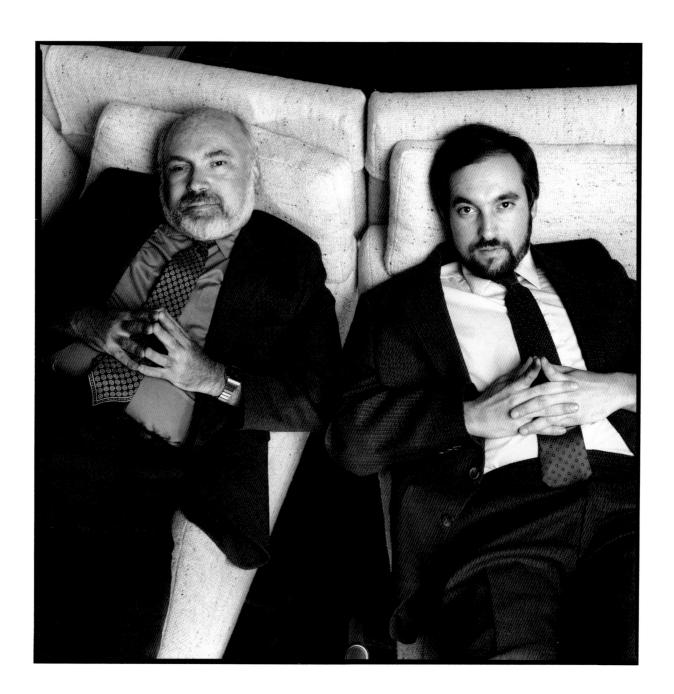

Galway Kinnell

Pulitzer Prize-winning poet, with

Fergus

THE OLIVE WOOD FIRE

When Fergus woke crying at night
I would carry him from his crib
to the rocking chair and sit holding him
before the fire of thousand-year-old olive wood,
which it took a quarter-hour of matches
and kindling to get burning right. Sometimes
—for reasons I never knew and he has forgotten—
even after his bottle the big tears
would keep rolling down his big cheeks
—the left cheek always more brilliant than the right—
and we would sit, some nights for hours,
rocking in the almost lightless light
eking itself out of the ancient wood,
and hold each other against the darkness,
his close behind and far away in the future,
mine I imagined all around.
One such time, fallen half-asleep myself,
I thought I heard a scream
—a flier crying out in horror
as he dropped fire on he didn't know what or whom,
or else a child thus set aflame—
and sat up alert. The olive wood fire
had burned low. In my arms lay Fergus,
fast asleep, left cheek glowing, God.

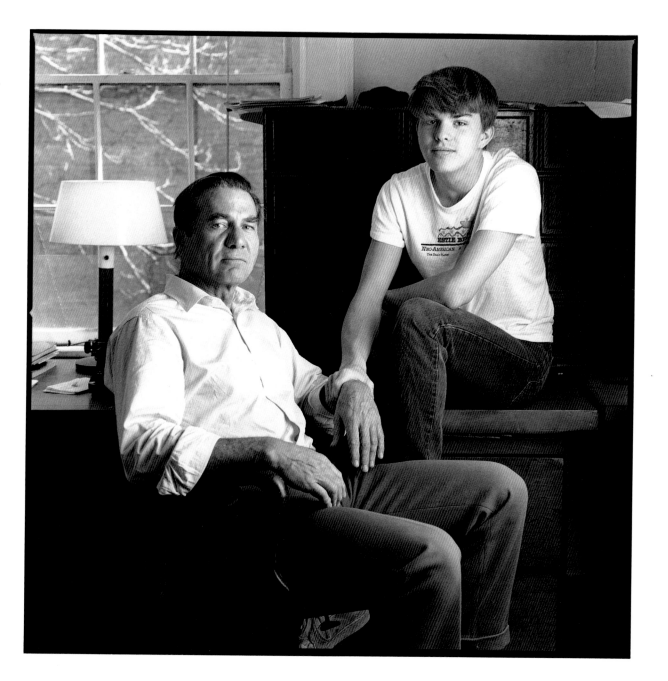

Mort Sahl

comic, with

Mort, Jr.

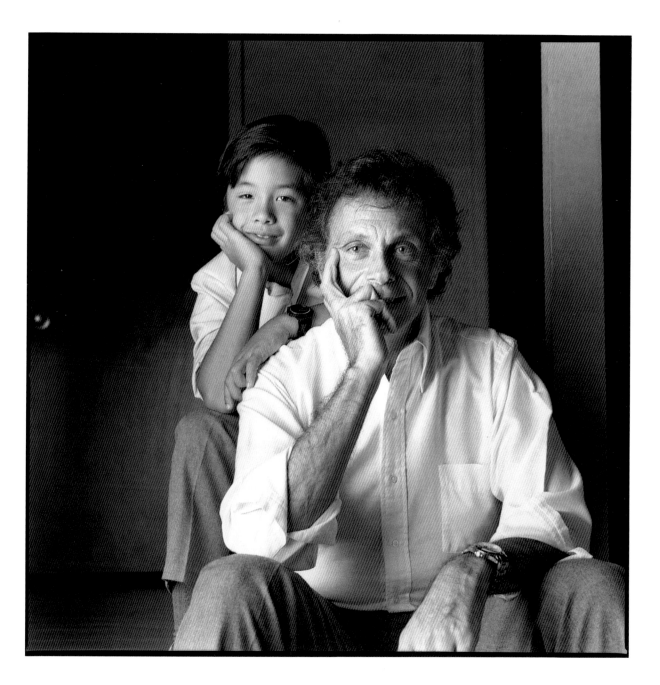

Nissim Vaadia

retired Israeli farmer, with

Boaz *(sculptor) and grandson* **Tal**

Being a father of an artist fills me with great satisfaction. His ability to master stone the way he does excites me, and I am very proud.
—Nissim Vaadia

From my father I received a great love of Mother Earth and the under-standing of the connection between man and nature.
With my son I learned the plea-sure of giving and the understand-ing of responsibilities.
Both relationships enrich my abil-ities as a sculptor and give me a bet-ter perspective on life.
—Boaz Vaadia

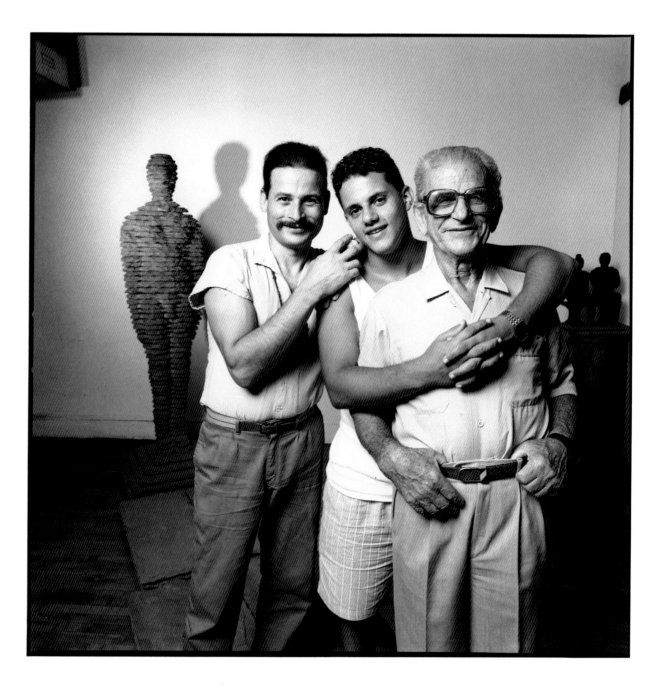

John Johansen

architect, with

Christen *and grandson* Daven

Watching Daven, our firstborn, grow up, Isabella and I have been aware of a piece of ourselves developing a life of its own. I feel my role as a father more acutely with Daven than with my second son. With Nicholas, I am more prepared. I watch his development with more understanding, and I know what to expect.

It is a wonderful feeling to share the lives of these boys with my wife. The experience is strengthening, it is also exhausting. —Christen Johansen

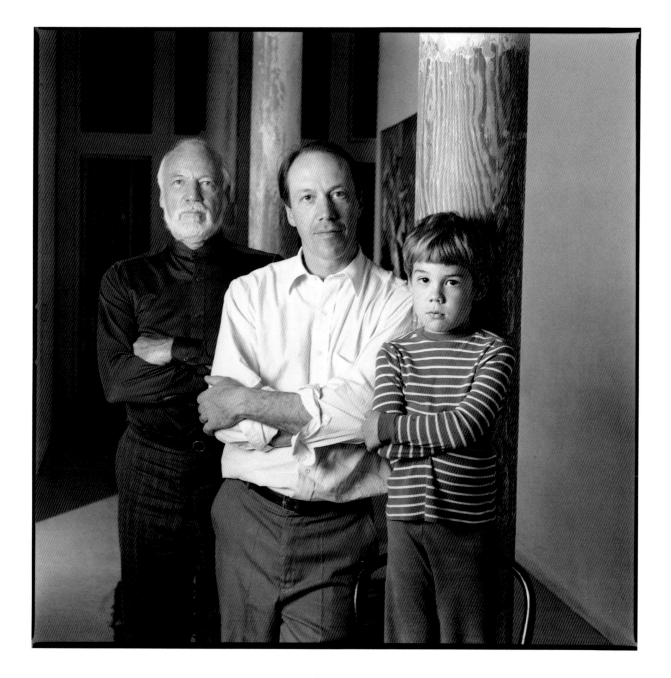

Paul Dooley

actor, with

Adam

Before my children were born (I have two daughters and two sons), I had the usual doubts about whether or not I'd make a good father. I was particularly worried about how I would relate to a son. My own father had been extremely distant, so I'd practice at a father–son relationship. That's one reason I'm so grateful that my son Adam and I are able to express our feelings for each other openly. When this picture was taken, we'd just been reunited after a long separation.

Being a father has been both easier and harder than I expected. I can't say I've handled every situation exactly right ... but I'm glad I can tell my sons how much I love them. I hope they won't be afraid to tell their sons, either.

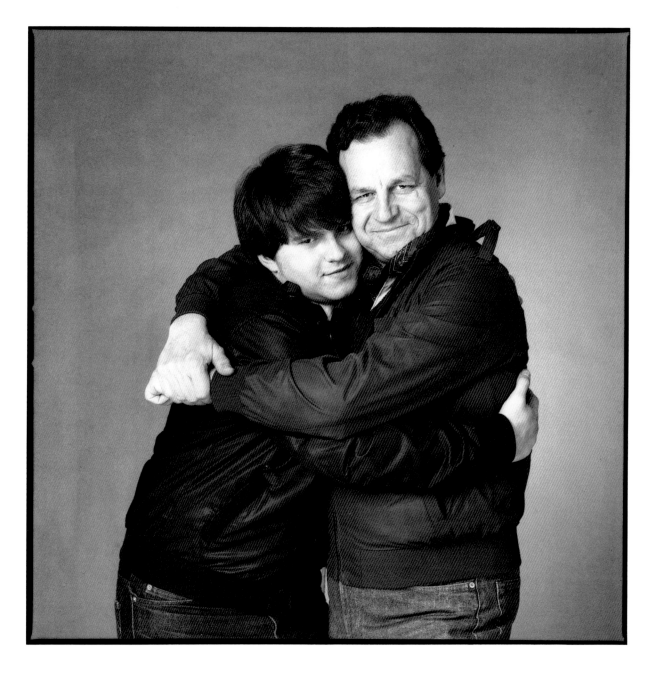

Dominick Oliver

president, Oliver's Pizza, with

Dominick, Jr., *and* **John**

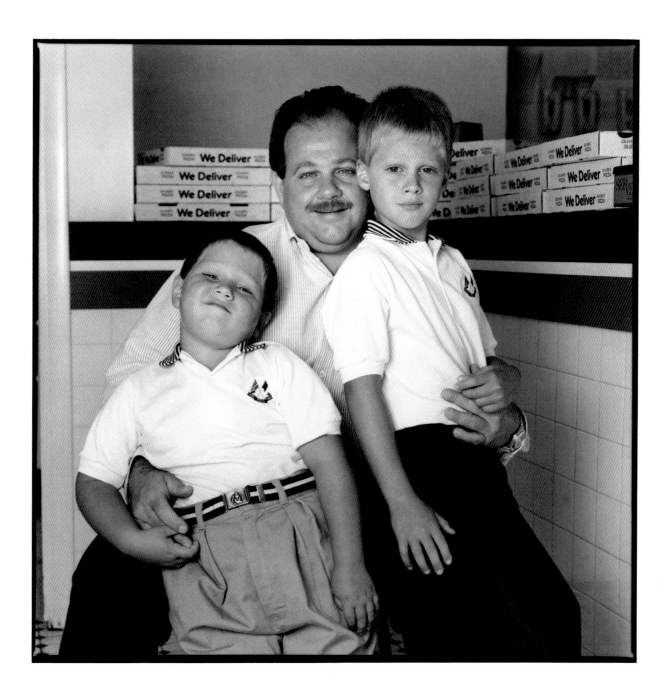

Bucky Pizzarelli

jazz musician, with

Martin *and* John

Having music in the family has been a blessing, both personally and professionally. When John and I work together as a duet, no two professional guitar players can do what we do. And being father and son adds a special dimension to our music—a spirit or tightness that no one can duplicate. Sometimes, raising kids can be very difficult for artists. I remember missing out on a lot of birthday parties when they were young because I'd be recording. But with them growing older and becoming musicians, it's worked the other way for us; it's made us closer. I feel real lucky as a father.

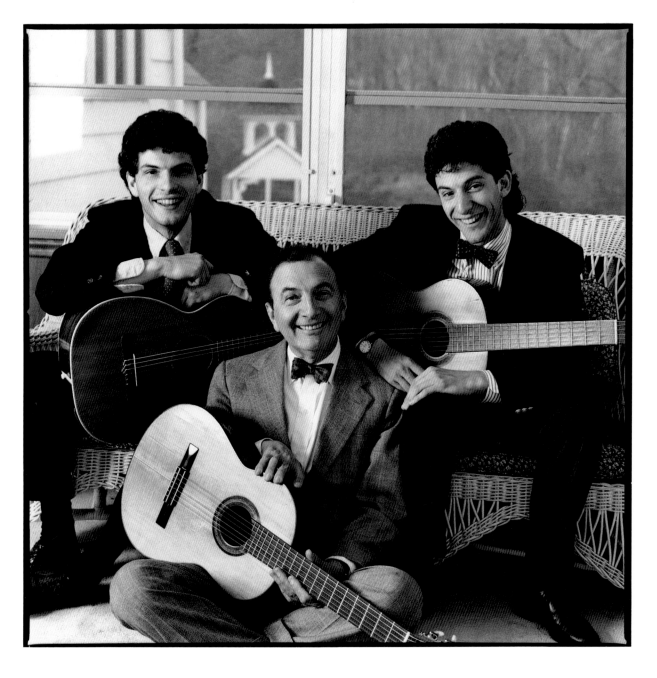

Earl MacFarlane

carpenter and trapper, with

Craig, *businessman and blind athlete*

Having two sons has made life great. I've enjoyed taking them fishing, hunting, and trapping. We had some exciting trips together. When Craig was hurt and blindness was the result, I tried always to treat him as if he had no problem. With his abounding energy and eagerness for life, this was rather easy to do. I followed Craig's sport career with great interest. I always encouraged him to do his best and was very proud of all his accomplishments. His wrestling career was my favorite and a source of great pride to me. Being Craig's father has been a sort of challenge to me, but in the end it has all been very rewarding.

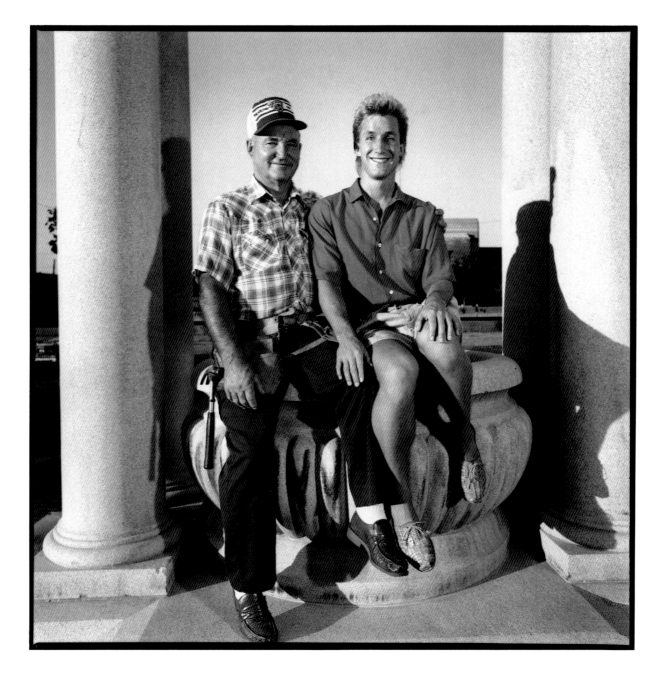

Major T. D. Butler (retired)

Royal Welch Fusiliers, with grandsons

Desmond *and* Tyssen *and son* George, *producer/director*

It made me more thoughtful. That sums it up in short, sharp terms.
—Maj. T. D. Butler

In 1949, my father's regiment, the Royal Welch Fusiliers, shipped out to Africa, and we spent three years in Somalia and Kenya. I still have strong early memories of my father teaching me to hunt in the desert, his back straight and the shotgun you see in this photograph locked on his forearm. This experience was not about killing game nearly as much as it was about heightening my senses, although when the day's stalk did not produce wild meat, something like roast camel would appear on the dinner table.

"Be quiet," he whispered more times than I care to remember. "If you're quiet and still and can fit into your surroundings and really use your eyes, you shall have no end of wonders to see."

I've always remembered this advice and used it. One day, in the White Mountains of New Hampshire, a running doe actually brushed my coat as it hurtled by and then stopped to look at me in disbelief. At other times I have been perilously, thrillingly close to wild grizzlies in Montana. As a filmmaker and photographer, I use every hunting skill my father taught me.

In the early '70s I watched my sons being born. On each occasion I was very alert, still, and in perfect harmony with the moment. No other experience has given me a greater feeling of rapture.

Then, as my father had done with me in Africa, I became a messenger to them, bearing my experience (and imperfect advice). As I speak to them, there is always this rustling in my chest when I catch myself telling them something my father, the Major, taught me. —George Butler

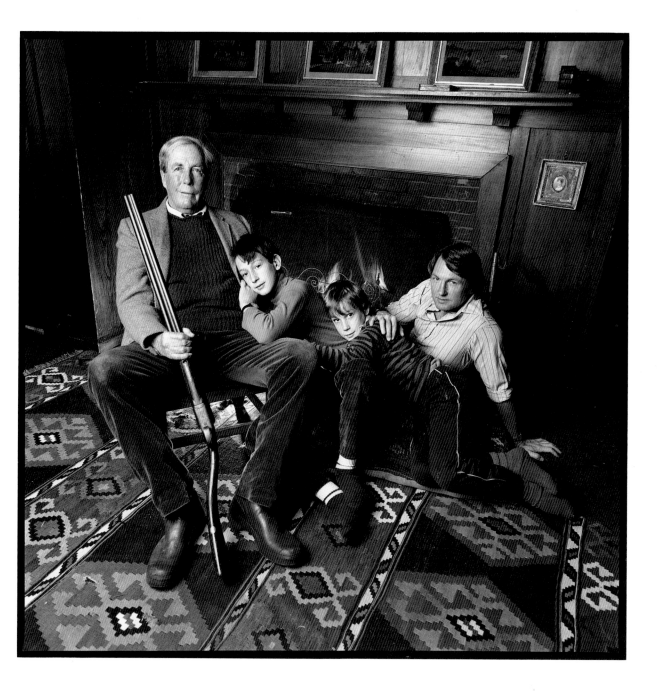

Rudolph Serra

sculptor, with

Owen

When I became a father, life took on a new perspective. The role my father played in the passages of my life was immediately, and still is, reflected upon. I view myself no longer as an end product, but merely as a pause in the continuum of life.

Although I have less time now, I find myself functioning better. I am more organized, and depression is a luxury I can no longer afford. The example my son sees is who I am today, not my fantasy of who I want to be tomorrow.

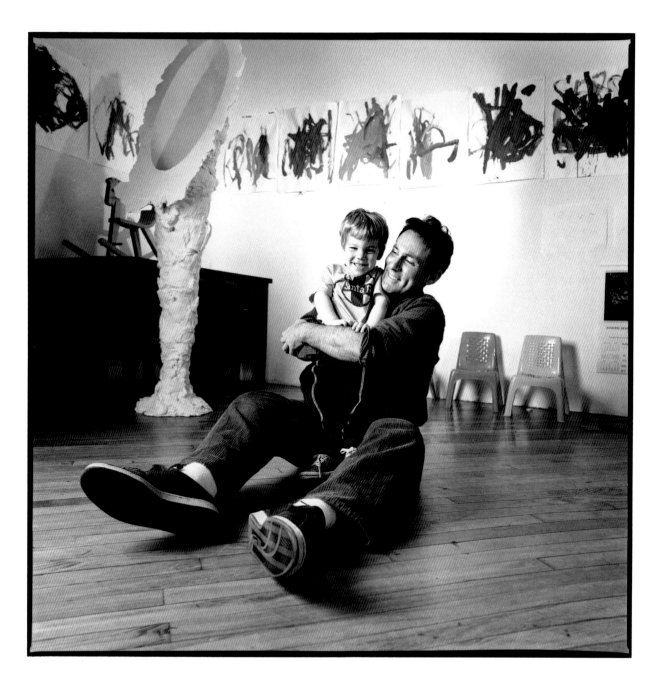

Bob Rafelson

film and television director, with

Peter

I found a friend for life.

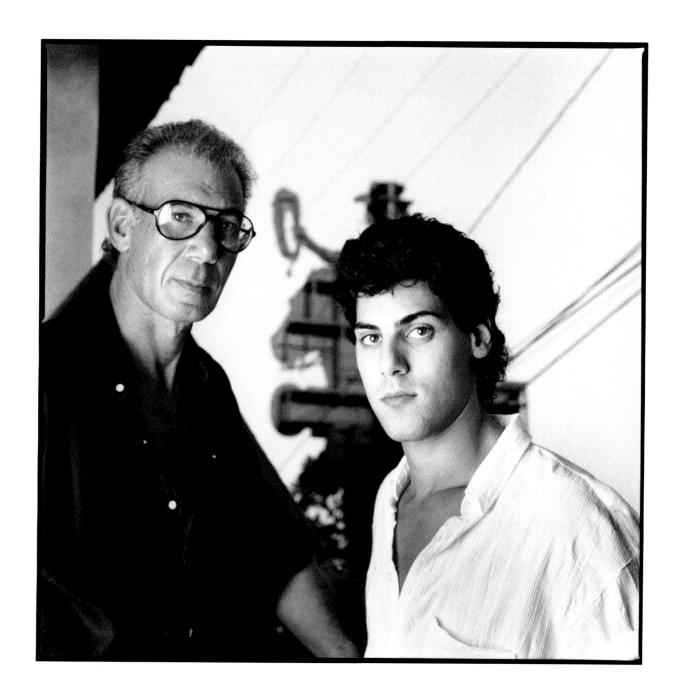

Mel Blanc

voice animator, with

Noel

My son gave me a chance to test my voices on a captive audience. If I gave him a dime he'd laugh real hard, and if I'd up it to a quarter he'd laugh all day. I'm glad he was only five or he would have asked for a lot more.

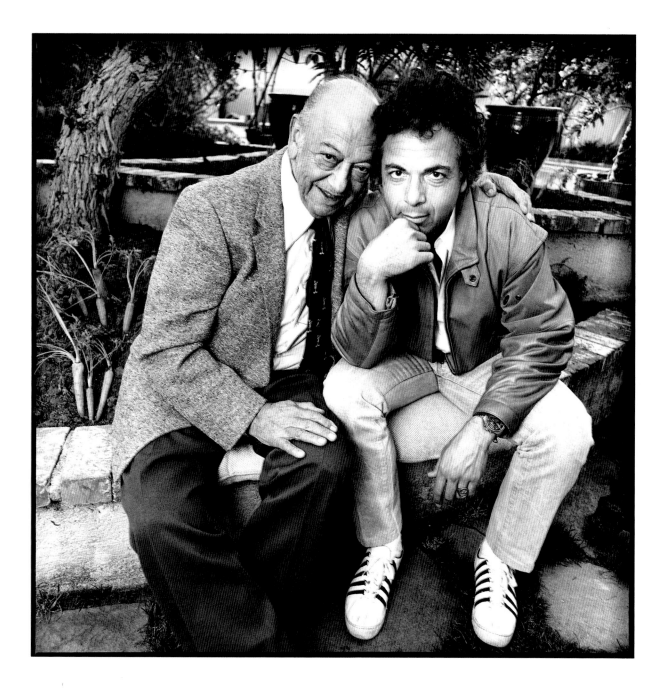

Edward Asner

actor, with

Matthew

The thought of turning an infant into a man scared the hell out of me— since I was still working on the father.

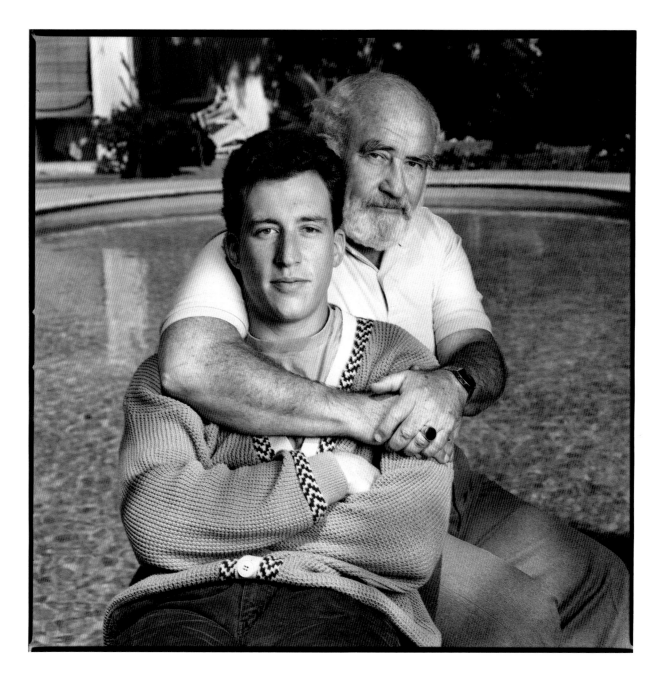

Oliver Lake

jazz musician, with

Oliver, Jr.

Becoming a father gave me a tremendous sense of pride, and I began understanding the meaning of responsibility. Kids need to eat everyday!

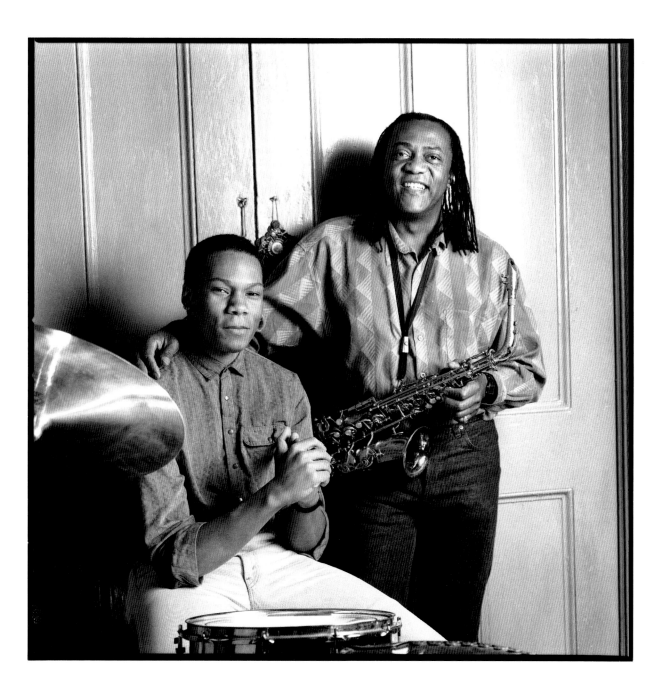

Ed Ruscha

artist, with

Ed

It was great, and it was mathematical. There was an addition, a couple of multiplications and divisions, but no subtractions.

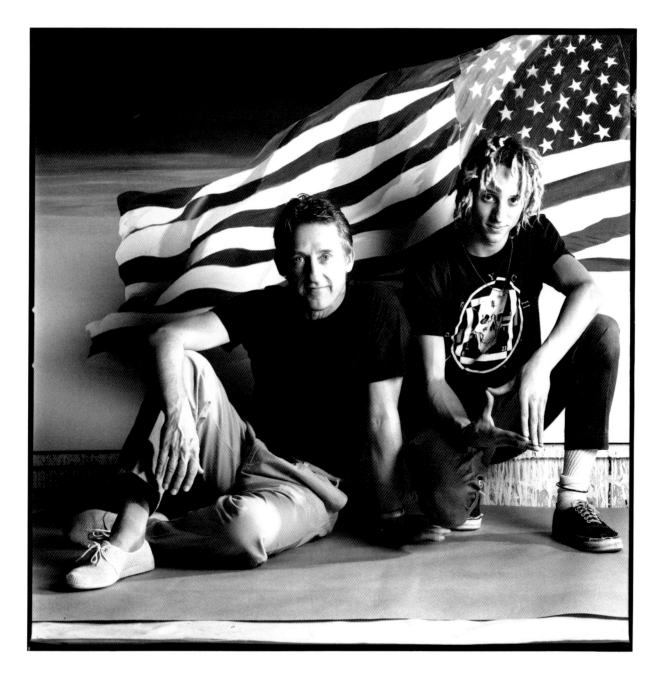

William M. Harris

video tape editor, ABC News, with

Eric

Eric's life has brought wonderment back to mine. His birth has caused me once again to look up at this world and has enabled me to see it in a new light.

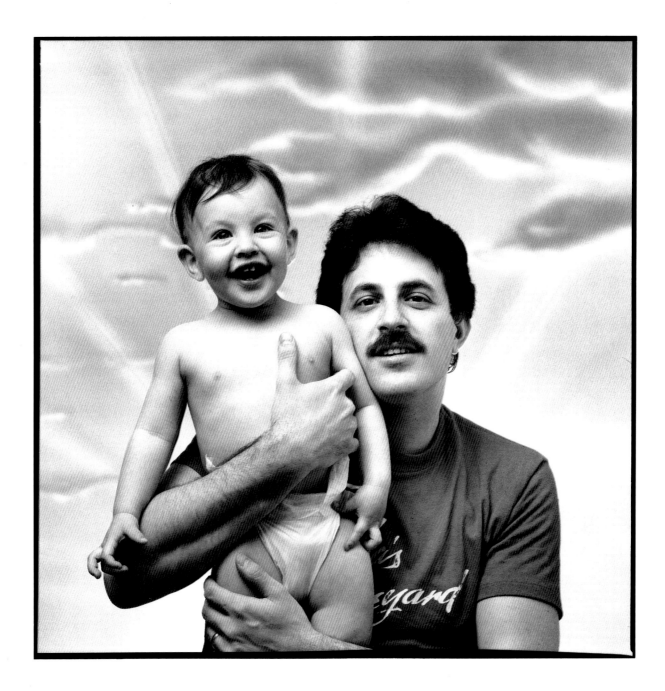

ACKNOWLEDGMENTS

I would like to thank the following people who in one way or another helped in the creation of this book. My wife, Amy London, who believed in me and stuck with me throughout the hard times. My mother, Ruth Begleiter German, and my sister Lisa Shewmon, who listened patiently to all my turmoil. To my assistants, who worked out of a love for photography, Laurent Niddam, Patrick Higgins, Ann Gibb, Claire Callahan, Sarah Young, Elie Porter, and Jo Caress. To Jim Stanton and Sid Kane, who helped me put the package together to take to the Frankfurt book fair. To Rusty Unger, Jane Farver, Tomoko Liguori, and Colleen Howe, who helped me find my subjects to photograph for this book. To Carla Weber, for hospitality. To Dave and Edith Liebschutz, for moral support. A big thanks to Paul Nunes, a good friend and my attorney, who gracefully guided me through my first book deal.

A special thanks to my publisher, Robert Abrams, who had the faith—and, I think, good judgment—to publish this book, and my editor Alan Axelrod and designer Jim Wageman, who rounded off the square corners. And to Gil and Eddie Acevedo of the Fine Print, for great black-and-white prints.

Finally I would like to thank all the fathers and sons who participated in this project.